Rajasthan
THE LIVING TRADITIONS

© Prakash Book Depot, 1999

Published by:
Prakash Book Depot
M-86, Connaught Place
New Delhi-110001
Phone: 91-11-3326897; Telefax: 91-11-3326566
E-mail: pbdepot@giasdl01.vsnl.net.in

No part of this publication can be
reproduced in any form or by any
means without the prior written
permission of the publisher.

Processed and printed at Thomson Press (India) Ltd.

ISBN 81-7234-031-1

Rajasthan
THE LIVING TRADITIONS

Prakash Books

CONTENTS

INTRODUCTION
Culture and Society 12
BY KOMAL KOTHARI

FAIRS AND FESTIVALS
A Celebration of Life 34
BY DHARMENDRA KANWAR

RITUALS, CEREMONIES, RELIGION
A Matter of Faith 56
BY KISHORE SINGH

FOLK MUSIC, DANCES AND PERFORMING ARTS
Rhythm and Resonance 78
BY MRIDUL BHASIN

CRAFTS AND TEXTILES
A Tradition of Craftsmanship 100
BY KALPANA MANGLIK

COSTUMES
Textile Traditions 122
BY CHANDRAMANI SINGH

NOMADS AND TRIBALS
The Face of a People 144
BY VIJAY VERMA

VILLAGE COMMUNITIES
The Tapestry of Rural Life 166
BY O P JOSHI

INTRODUCTION
Culture and Society

The cultural identity of any region is based on the dominant groups inhabiting the area, and their means of livelihood; it also includes within its ambit the minutest of human expressions. In this and other regards, Rajasthan's fabric of culture is unique with its multifarious textures and folds, each with its own shade and beauty.

Geographically, the region can be divided into three broad categories — the first, forming part of the great Thar desert, the second, its ancient Aravalli tract, and the third, its fertile plains. All three regions make up the state's ecological environment of arid and semi-arid zones. Historically, Rajasthan had always been governed by princely states under the dominance of central, imperial control. Its history has contributed great warriors and heroes, their brave deeds resulting from a desire to remain independent. The official histories of different ruling families present a long list of leadership qualities and exemplary patterns of bravery.

The princely kingdoms of Rajasthan merged as one state in the Indian union after Independence, thanks to the efforts of Sardar Vallabhbhai Patel. Though the state did not have a common political and administrative entity prior to this, its socio-cultural history was knit on the basis of its history, life patterns, value systems, and linguistic unity.

From the seventh century on, Maru Bhasha was recognised as the language of Rajasthan. By the eleventh century, great epics such as Chand Bardai's Prithviraj Raso had come into existence. This great tradition of written literature continues till today through a large number of heroic epics, legendary ballads, stirring poetry, devotional compositions, works on prosody (Alankar and Chhand), dictionaries (Nam Mahas), tales in prose, and critical treatises on philosophy, religion, logic, and medicine. The tradition of Jain and Charan literature has enriched cultural discourse in recording historical events and people's aspirations through the common mode of language.

Such literature provided the mirror to the social realities of this region. The desert community had its base in a pastoral economy, yet agriculture took a back seat to the raising and rearing of cows, bullocks, sheep, goats, camels and horses. This entailed moving with the herds in order to find fresh grazing pastures, and for breeding and selling at various fairs. This pattern created its own compulsions and resulted in inspirational, oral epics based on pastoral heroes such as Goga, Pabu, Deo-Narayan, and Teja, who lived between the eleventh and sixteenth centuries. Their heroic exploits find their genesis in the practices of cow rearing, and the protection of cattle. Eventually, these heroes were deified, and even today are worshipped as gods. Goga and Teja, for example, are believed to be able to protect, and even cure, people against snake bites and poison. The major event or adventure in these epics relates to the kidnapping of cows with the heroes out to reclaim them. In the ensuing war,

A dazzling crowd of women gather to celebrate Gangaur, a women's festival where they pray for fidelity and marital bliss. The clothes they wear are at great variance with their environment.

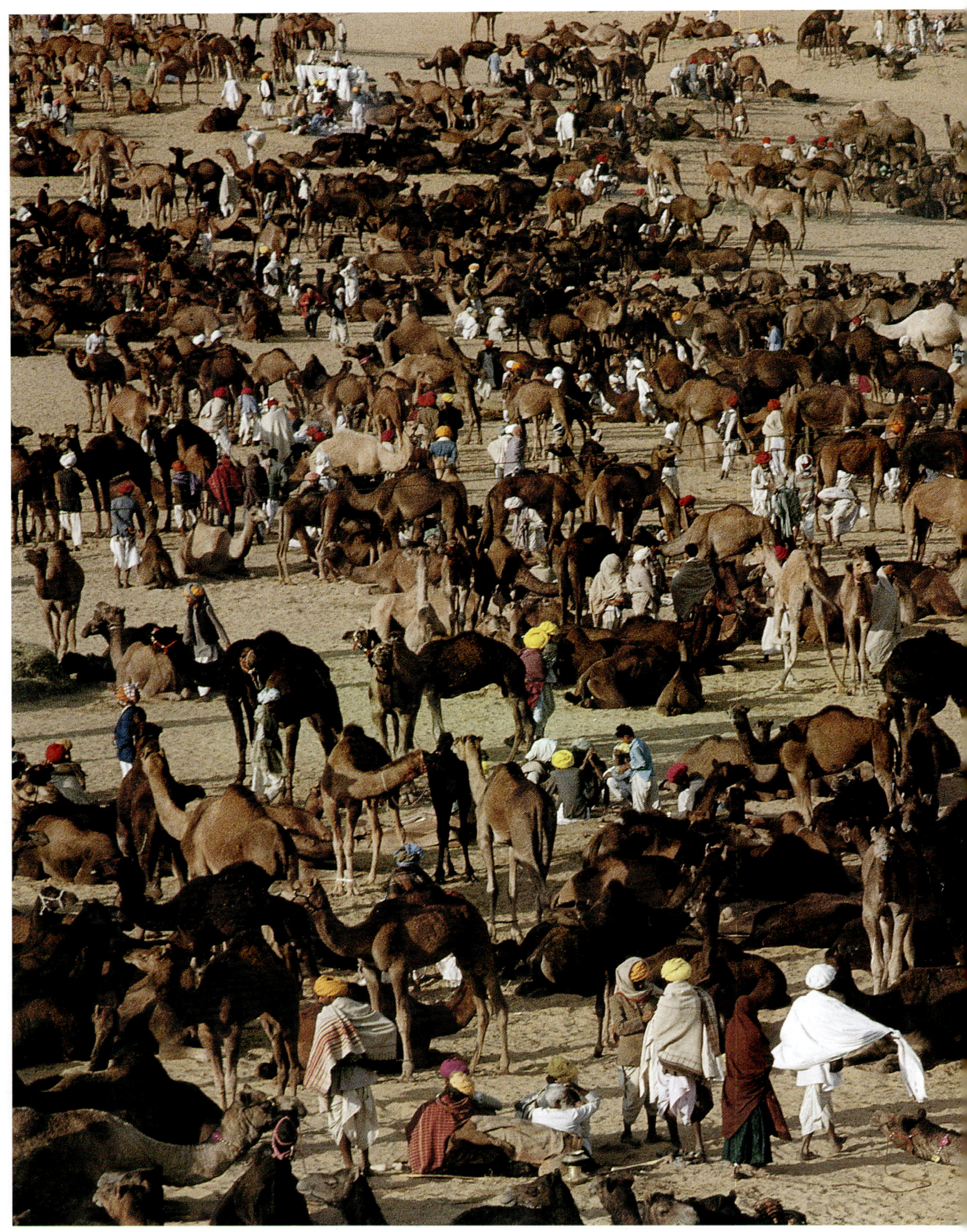
At the annual Pushkar Mela, people from all over the state come together to trade in camels at the world's largest such fair, and evocative of an experience that has probably remained unchanged for millenia.

Etchings and drawings by Europeans show a great fondness for the Rajputs, depicted here as warriors who carry their everyday arms with a relaxed insouciance, while the parted beard and proud countenance of a Rajput noble is captured with great dignity.

BUDDUN SING, RAHTORE

the hero is killed but referred to as journeying to the heavens. Thus, he lives forever. This cultural motif is available in practically every village. Folk gods such as Bhomia, Palyaar and Mamaji usually belong to this category.

It is amazing to see that such heroes have inspired oral epics and performing formats that include melodic forms. Goga's story is sung with the musical instrument *deru*, Pabuji's story accompanied by music from the *ravanhattha*, and Deo-Narayan's story with musical instruments like *jantar*, while the tales of ancestral gods are rendered on the *dhak*.

The hilly tracts of the Aravallis are inhabited by tribal groups such as the Bhils, Minas and Garasias who have been dependent on the forest and its produce. Again, agriculture was not a major economic activity for them, and tribal life helped enrich their culture through institutionalised group disciplines. A close-knit social organisation was their basic unit of survival, and all aesthetic and performing skills were directed towards achieving this homogeneity and identity. Their dances and songs were performed by large groups of men and women. Their religio-social practices gave birth to the cult of ancestral gods and mother goddesses. All of their aesthetic life moved around these faiths.

Each village has its own shrine in a hut or under a tree with beautiful icons made from clay, wood, stone, or metal, crafted by artists within the group itself. At times, certain objects were collected from specialised groups outside their own. The *kumhars* or potters of village Molela, for example, made clay icons with excellent abstractions, supplying them to the tribes. Similarly, the stone-carvers of Rishabdeo made thousands of sculptured figures in the memory of their ancestors, the male forms being known as Soora, the female Matlok. These carved-stones are not standardised but attempt to deal with the cause of each person's death which may vary from murder, snake bite or death caused by a wild animal to various illnesses, childbirth, or accidents. It was expected that the stone carver would design the stone in such a way as to give expression to the cause of death. This resulted in his having to create friezes to convey the story leading up to the death, and as a result common motifs came to be used to imply certain common events.

No tribal custom is celebrated by an individual or a family, but involves larger social groups. This has given rise to the tradition of big festivals and fairs in each region. Such events are governed by the time cycle of calendars that revolve round the week, the fortnight, the month or the year in which summer, rain and winter intervene cyclically. It is in this logic of cycles that festivals such as Gavari and Rai find a place. During the rains (Bhadva-Asoj), for example, these tribal communities enact the folk dance drama Gavari for forty days in forty different villages. Since some four to five hundred villages independently enact Gavari, its enactment can reach as many as sixteen thousand different habitations. The Gavari dance-drama holds the key to the mythological treasure of the tribals. These myths have provided the opportunity to evolve aesthetic and artistic objects like masks, clay images, wood carving, ornaments, and woven and printed cloths. The mother goddess epics form the bulk of their oral literature.

Above: Archival photographs show a gathering of princes that signals the start of the celebrations that mark a royal wedding, while another depicts a formal procession leaving the gateway of Bikaner's Junagarh Fort to step out into the city.
Right: The proud face of a warrior peeps out from behind the columns of a royal residence. It was the motto of these warriors to serve their kings and their motherland, and death was never an issue for them.
Following page: The kings raised beautiful kingdoms in the desert, and extended their patronage to artisans who created such exquisite architecture as these havelis in Jaisalmer. Whether their clothes, architecture or utensils, the people tended to decorate their everyday environment.

The third of the geographical regions consists of the fertile plains that respond well to agriculture, though the semi-arid ecology keeps them bound to non-agricultural practices of cattle raising and dairy produce. The dominant groups in this region are Gujjar and Mina, and the Deo-Narayan epic revels in the basic struggle between cow-herders and agriculturists. Cow herders need large areas for grazing while farmers need safe enclosures for cultivation. In the medieval period this contradiction developed into a social problem and before either reconciliation or mediation, it resulted in grave social tension and a fight to the finish. Twenty-four Bagdawat brothers had to sacrifice their lives, we are informed, to gain grazing rights for their cattle.

Another great epic of this region is the well-recognised romantic tale of Heer-Ranjha, usually associated with the folklore of Punjab, and to an extent recognised as the medieval work of the Sufi poet Varis Shah. The poet's version of the story of Heer-Ranjha aims to project the deep philosophy of Sufisim, and as a symbol of supreme love. But a local version of the same story is rendered by people to save their cattle from epidemic diseases. It is said that in eastern Rajasthan, whenever there is a cattle epidemic, the tale of Heer-Ranjha is religiously recited in the nature of a 'path'. A 'path' signifies the absolute faith or belief through which meditation is desired. This story is recited by Jogis accompanied on the *jogia sarangi*, as well as by farming groups with or without musical instruments.

If the different oral epics help to highlight the regional variations of culture, and of deep-rooted physical and spiritual aspirations, the food habits are another way of nurturing this. The desert belt produces and consumes *bajra* (pearl millet), the Aravalli region has *makka* (maize), and the fertile plains grow *jowar* (sorghum), and these form the staple crops. Interestingly, these have also created the distinctive patterns of tribal societies associated with their produce and consumption. The *bajra* growing regions have a tribal population, while the *jowar* producing belt is dominated by the Gujars. These dominant groups played an important role in creating the cultural milieu of each region. These zones were never totally

Left: These village women have come to participate in a fair dressed in the bright dresses and silver jewellery that is part of their daily wear. Women, particularly, wear a lot of jewellery even when going about their daily chores.
Top: In the desert, the camel is still the most reliable means of transport, particularly where there are no roads. In the summer months, when the winds shift even the dunes, the camel is useful for plotting a route between villages deep in the heart of the Thar.
Above: Lakes are not uncommon in the desert, some man-made, others natural, and these have served as watering points for cattle, as well as for the wildlife in the region. In the past, lakes were also associated with hunting preserves, and the process of shikar was a skill that combined horsemanship with the thrill of the chase.

cut off from each other and large areas actually overlapped, forming a junction where two or three different grains appeared simultaneously. To draw a cultural scenario based on the geographic and staple food zones provides a different cultural understanding of Rajasthan.

A glimpse into a people's way of life provides another dimension of aesthetics and creative arts which results from specialisation and excellence. These cultural forms are rooted in people's needs, desires and aspirations. It in this context that we must try to understand the great tradition of Rajput miniature paintings. It is true that paper arrived in the thirteenth-fourteenth century, with earlier paintings done on cloth or *bhojpatra*. With the arrival of paper, painting techniques needed to be modified, and colours, brushes, the medium of sketching, everything had to adjust to this new base.

To trace the history of the Rajput style of painting, we might have to take a closer look at traditional cloth paintings available in the form of the painted scrolls of Pabuji and Deo-Narayan, or of the Krishna temple cloth paintings from Nathdwara and Kishangarh. These traditions have continued till today and help to provide the link when paper, as a base, began to replace cloth. In the same period one can find large numbers of illustrated manuscripts. The demand for such material came from the social elite who consisted of the business communities and ruling clans. The elite were spread all over Rajasthan, and employed groups of painters who painted exclusively for them. The patronage threw up some excellent, creative artists who usually found their

Above: Caparisoned elephants, their hides painted in colourful motifs using vegetable colours, are indicative of the start of most festivities. Painting these elephants has evolved into a great art in Rajasthan, and especially so in Rajasthan.
Left: An elephant in the hilltop fort of Amber – these pachyderms were once symbols of a kingdom's might, and they were important to the princely order. They were used for carrying their kings in procession, as well as trained for battering the spiked-gates that protected most entrances to the forts.

particular expression in palace ateliers. Such families demanded from these artists the commission of family portraits, court scenes, dance and music sessions, royal processions, hunting adventures, and animal life as represented by horses, elephants, wild boars and the like; they also commissioned classical texts such as Ragamala and Nayikabhed.

Rajasthani society is aesthetically rich and can make most utilitarian objects decorative and ornamental. Simple kitchenware such as tongs, pots, pitchers, and vessels are made ornamental, while even vehicles like bullock carts and chariots were designed with minute care. In their huts one can find finely worked storing spaces. Saddles for camels, horses, and elephants are a showcase of their skills. Whether it be the brass ornaments of tribal people, the silver ornaments of ordinary people, or the gold and precious stone jewellery of the elite groups, it is difficult to escape the significance given to them in their making.

The tradition of male and female wear is rich in colour, and creates a special identity for the wearer, whether young or old. Society is stratified through the colours one wears, so one is able to tell whether a woman is married, unmarried, or a widow. Even the handblock prints provide different community groups with different patterns and designs. This is how textile aesthetics have found such a vibrant place in contemporary economy.

Where does the cue to this all-pervading rich cultural manifestation lie? A closer look needs to be given to occupational caste groups like the *sonar* (goldsmith), *lohar* (ironsmith), *mochi* (cobbler), *khati* (carpenter), *chitera* (painter), *lakhara* (lacquer maker), *bherava* (metal caster), *niheria* (metal separator), *kumhar* (potter), and *silawat* (stone worker); the list can be longer and more exhaustive. These caste groups perpetuate the skills in their own group by transmitting the knowledge, tools, technique and the recognition of raw material with its potentiality. The traditional process of learning these skills is by passing them on to successive generations, communicating not theoretically or structurally but via the process of practical workmanship. From early childhood, a caste member joins the tradition of creating beautiful, utilitarian objects. The physical environment and cultural ethos in Rajasthan are the contribution of such castes. Whether a richly sculptured temple, a tall and empowering fort or palace, a beautifully painted *haveli*, a *bund* or a man-made lake, or a simple house in a town: these are the accomplishments of the different craft groups enumerated above. While it is true that the financial and economic contribution was the task of the royalty or the court officers or the rich business community with their demand for aesthetics, the execution of such cultural objects remained in the hands of the masters of different skills.

But the creation of physical objects — big or small — is not the sum total of cultural life. Culture is beyond it: it is a way of life, of behaviour, of spiritual atonement or achievement. Nor is culture always social, it concerns

Polo, the sport of kings, and the king of sports, continues to be widely played in Rajasthan, supported by the Indian cavalry, and by teams maintained by some of the heads of the erstwhile ruling families.

each individual and his contribution to society. However, each individual is a product or creation of the cultural milieu with a role in society that is defined.

These human relationships are institutionalised by cultural as well as practical considerations. The birth of a child, marriage and death are the three most important *sanskars* in the life of each member of society. Indian society has a total of sixteen different *sanskars*, each with its own initiation ceremonies. These are elaborate functions, and they are accompanied by folk songs, dances, and meeting defined social commitments. Though such practices are universal, different regions and groups of human society organise them to suit their own identity. A wedding ceremony, for example, conducted in the traditional way, may take a month or more in Rajasthan: right from establishing the god of well being, Vinayak, to the Bindori feast invitations, the ceremonial march of the wedding party with the bridegroom riding a mare, the reception at the bride's house, and hundreds of responsibilities are built into the ceremony. Birth and death ceremonies operate on a similar scale. It is at this level that the role of the Bhats (genealogists), Raos or Jagas (panagyries), Dholis, Dhadhis, Langas and Manganiyars (musicians), and the Pandas (recorders of death) at Hardwar, Gaya and Pushkar become culturally important. No caste groups can be recognised without the dependent castes mentioned above to serve them.

The final desire of any human being is to achieve *moksha* or salvation. This involves man's belief in spirituality, normally defined as religion. However, the larger concept of spirituality is based in philosophy which provides the logical contours to understanding the wider realities of nature and human effort. In Rajasthan, a number of philosophic movements arose, among them various Shaiv and Shakti groups. The Jain tradition, through the Digambar and Swetambar sects, has contributed to human understanding through various written treatises.

The story of the cultural life of people is endless: bottomless as a deep sea, and as vast as the spreading sky. My efforts at attempting to understand this cultural life are little more than the smallest drop of water in a vast ocean of knowledge. Let us all build society and endeavour to elevate the joy of being human.

Above: An elephant makes its way down from Amber to Jaipur, bridging the gap between the old and new capitals of the Kachchwaha rulers of this former princely state.
Right above: The ramparts of Bikaner's Junagarh Fort are protected by a moat, while within its battlements lie sandstone apartments of exquisite beauty.

FAIRS AND FESTIVALS
A Celebration of Life

Rajasthan loves to celebrate, its people expressing themselves in colour and sound not seen or heard elsewhere in the country. Vibrant colours, music and festivities make this golden land come alive. This love for colour and joyous celebrations is apparent in the elaborate rituals and the gay abandon with which the Rajasthani surrenders himself to the numerous fairs and festivals celebrated in the state. Take any month of the year — from the first to the last — and you are sure to find some festival or celebration happening somewhere. These *melas* help the otherwise hard-working villagers to relax in the company of their brethren, and provide villagers from far-flung villages an opportunity to gather for social or commercial purposes.

The festivals celebrated here, as in the rest of the country, are marked by religious, mythological, seasonal or historical significance. Certain days or periods of time have been set aside to commemorate and ritually celebrate these events. Other than these traditional fairs, some non-traditional fairs are now being organised by the Department of Tourism.

At religious fairs, worship, prayer and processions play an important part. The faithful flock to centres of pilgrimage where they pay homage to local saints and folk heroes. Temples built in their memory, and all spots associated with their life and times, are revered. Equally important are the fairs associated with the changing seasons. As agricultural operations follow the cycle of seasons, it is during the intervals that the celebrations usually occur. There are fairs to welcome the monsoon, fairs to welcome spring, and fairs to pray for a good season. Agricultural fairs provide the farmers a chance to get together with their clansmen and celebrate with song and dance. They even have songs for every aspect of farming — planting, transplanting, harvesting, threshing. They also offer prayers to the rain gods for a plentiful harvest, or in thanksgiving for a good harvest. Sociocultural fairs, on the other hand, provide meaning and cohesiveness to an individual's standing in society and help create harmony among the members of not only the entire community but also the entire village. Traditions are maintained and a feeling of solidarity is kept alive through these festivals. This is especially true of fairs associated with individual villages, temples, or with specific communities and cults that provide educational, social as well as a religious character.

Whatever the occasion, a joyous spirit pervades — there are rituals, colour, music, feasting, pageantry, trade, fun and frolic. The love of colourful clothes and dressing up in the most amazing traditional jewellery is nowhere more apparent than at these times. The bustling bazaars provide the villagers an opportunity to participate in the trading of cattle and grain, and the womenfolk take great delight in buying new clothes as well as household goods. There is also brisk trading in traditional arts and handicrafts. In fact, most of Rajasthan's traditional crafts are kept alive at these fairs. The sales at these markets make it possible for the village craftsmen to survive.

Another important aspect of these *melas* are the traditional entertainers — the minstrels, jugglers, puppeteers and performers who provide hours of pleasant diversion as they come together at the fairs. Religious mendicants sing devotional songs. Elaborate enactments of episodes connected with the occasion are staged which help the people to understand the mythological and philosophical aspects of their religion. Traditional

The celebration of a festival provides the occasion for people from all around to gather, as much for social as religious and commercial reasons, and they use every transport at their command to make the journey. Camels, elephants or bullocks are colourfully decorated to participate in parades, or just to carry people.

folklore is retold through social events and interaction, and this helps the people to understand their origin, identity and destiny.

The Hindu calendar, based on the lunar revolutions, is the oldest system in the world, and one that is still widely followed in India. It divides the year into twelve lunar months of approximately twenty-seven or twenty-eight days each. Since the Indian months, and their seasons, are very important, it is necessary to understand the seasons into which the year is divided. In Rajasthan, as in other parts of the country, the year is divided into six seasons: Vasant or spring (mid-March to mid-May), Grishma or summer (mid-May to mid-July), Varsha or monsoon (mid-July to mid-September), Sharad or autumn (mid-September to mid-November), Hemanta or winter (mid-November to mid-January), and Shishir or the period of dews (mid-January to mid-March).

Though the fairs and festivals fall within the Hindu calendar, it is easier to understand and document them keeping in mind the Gregorian calendar months. Unlike the Gregorian calendar, the Hindu months spill into the other months of the English calendar: for instance, the month of Pausa covers half of December and half of January, while Magha stretches from mid-January to mid-February. Though a little complicated, it is important to note that the division of months depends primarily on the lunar revolutions, and so fairs and festivals do not fall on the same day each year.

The first quarter of the year has the Indian months of Pausa-Magha, Phalgun and Chaitra that fall in January, February and March. These are the months when the desert state is still cold, and the people are in the mood to celebrate. No wonder these months are filled with so many fairs and festivals.

The year starts on a lively note with the Camel Festival in Bikaner, held every year in January. Bikaner is certainly the right place to come in contact with the camel, especially when it participates in a number of activities that range from parades to races, dances — yes! these animals can dance too! — and acrobatics. The two days of festivities end with the folk performers joining in to display their art. There is *gair* dance as well as the awe-inspiring fire dance that keeps the visitors glued to the edge of their seats.

Soon after, Jaipur and Jodhpur gear up to celebrate the annual kite flying festival of Makar Sankranti which falls, every year, on the 14th of January. This marks the sun's entry into the northern hemisphere and also signals the end of winter. The skies are dotted with thousands of colourful paper kites. Families gather on rooftops, playing loud music and fighting over proprietorship of kites that they 'cut' with their strings while soaring in the sky. Shouts of "*woh kata*" ("well cut") rend the air when a kite is brought down. An interesting sight is of street children with a long stick in one hand, and a pile of 'looted' kites in the other. People pray for a good harvest and offerings of *til,* sesame, and *khichdi,* a porridge of millets, is made to Surya, the sun god.

In Nagaur, 145 km from Jodhpur, the people gather to participate in the second largest animal fair of the year in the state. Held during the month of Magh, this fair is renowned for its trading of cows, bullocks, camels and horses. The colourful bazaars give the visitors ample opportunity to shop as they move in groups and allow themselves to be entertained by folk performers.

The Desert Festival at Jaisalmer is a perfect three-day show on the sands. Held in the month of January/

Top and right: Images of Shiva and Parvati, dressed resplendently, are carried in formal processions to celebrate Gangaur, a festival that is distinctive in Rajasthan. The women who accompany the idols wear the auspicious red, the colour associated with the ritual of marriage.
Above: Decorated camels at Jaisalmer's Desert Festival, now a major attraction especially organised for showcasing the region's heritage.

February, this festival culminates on Magh Poornima (full moon day) and showcases Rajasthan's rich cultural heritage. Men and women dressed in their traditional best attract as much attention as the dancers who sway to the beat of folk instruments. Camels are decorated and dressed in finery to participate in races, and performances are held on the beautiful sand dunes of Sam. The entire city is decorated to receive visitors from all over the country. The golden fort is especially illuminated for the event. The three days are packed with several activities that make this festival a not-to-be-missed event.

Magh Shukla Ekadashi marks the beginning of the largest tribal fair — the Beneshwar Fair that is held in Dungarpur district. Beneshwar is sacred for the tribal communities of Rajasthan and the neighbouring states of Gujarat and Madhya Pradesh. On the occasion, the tribals immerse the ashes of their deceased in the holy waters here. Thousands of devotees gather near the confluence of the Mahi and Som rivers. Beneshwar, literally 'the master of the delta', is devoted to the worship of the revered Shiva *linga* which is brought here from the Mahadeo temple in Dungarpur. The religious celebrations are combined with much festivity, and the tribal camps make a colourful and breathtaking sight.

The Shekhawati Festival is held in February and serves as an introduction to this beautiful region. Organised jointly by the government and a private agency, this is essentially an effort towards the promotion of rural tourism. The festival is spread over a number of Shekhawati's painted towns — Nawalgarh, Sikar, Jhunjhunu, and Churu. The visitors are introduced to jeep and camel safaris and cultural programmes, and the organisers are hopeful that this exposure will encourage the owners of the painted *havelis* to preserve their priceless heritage. This is the best opportunity for visiting this fascinating region and exploring the exquisitely painted mansions. The local folk artists stage performances that are unique to this region. Since it is still young, the festival has begun to add attractions such as horse shows and safaris to its repertoire.

In the middle of Phalgun, it is time for the most important festival in this quarter — the festival of colours, Holi. This festival symbolises the end of winter and the arrival of spring. For the farmers, it is a time to celebrate for the wheat harvest is ready, and they can relax after months of back-breaking labour in the fields. An important mythological aspect connected with the festival is the story of Bhakta Prahlad, a devotee of Lord Vishnu, who was carried into the fire by the female demon Holika when he persisted in worshipping Lord Vishnu. Prahlad emerged unharmed while Holika was burnt to ashes. Bonfires are lit to commemorate this event which marks the triumph of virtue and religion over evil. People from all walks of life put coloured powder and water on each other, and also attempt to reconcile any quarrels they may have had with friends or members of the family.

For the people of Bharatpur region, Holi is a special festival dedicated to their beloved Lord Krishna. Celebrations begin days before the actual day of Holi and everyone seems to be touched by the boisterous spirit of the Braj Festival. Villagers enact the Rasleela — the immortal love play of Radha and Krishna — through song and dance.

In Jaipur, the Elephant Festival held on the occasion of Holi attracts thousands of visitors who delight in watching the huge animals dressed in all their finery as they are led in a procession to participate in elephant polo

matches, and races. The elephants are caparisoned, their wrinkled hides covered in elaborate body paint, while embroidered velvet saddle-cloths and jewellery are used for their adornment.

The day after Holi marks the beginning of yet another festival, Gangaur. A festival of and for women, and marked with great fervour and devotion, Gangaur is the combination of the names of Lord Shiva and his consort Parvati.(*Gan* is another name for Shiva, and *Gaur* or *Gauri* the name for Parvati.) Gangaur is celebrated all over the state, though with minor variations. The period of the festival is marked by elaborate rituals. In Nathdwara, near Udaipur, the entire township gathers near the temple of Shrinathji for seven consecutive days to watch the idol of Gauri being taken in procession. On each of the seven days, the participants choose a different colour scheme for their clothes. There are special *poojas* or prayers for the occasion. Women all over Rajasthan spend the entire period following elaborate rituals that include prayers, processions, fasting and feasting. Virgins pray to the goddess for a meritorious husband, while married women pray for the long and prosperous life of their husbands. In Jaipur, a special sweet called *ghevar* is widely consumed but the highlight of the festival is the colourful, ceremonial procession that is taken out from Tripolia Gate to Chaugan and then on to Talkatora. The images of Gauri and Isar are carried in palanquins and accompanied by elaborately decorated elephants, camels and horses, and smartly dressed attendants. The final rites are marked by the immersion of the images in a holy tank or lake.

Celebrations are community events, and people's participation in them is intended to strengthen their close ties, whether they are local fairs, religious occasions, or trading events. Often, therefore, they are all three simultaneously.
Right: The celebration of Gangaur in Jaipur revokes nostalgia for the past, and the procession enacts the route undertaken by the idols from the palace through the city's streets, allowing people to participate in the festivities.

41

During the festival of Holi, coloured powders and water are used for sprinkling on each other, while the re-enactment of Krishna's Rasleela is associated with the song and dance linked with this period.

43

In Udaipur, Gangaur coincides with the Mewar Festival. The traditional Gangaur boat carries the procession across Lake Pichola, as has been the custom since several years. All over the city, married women and young girls dressed in their best can be seen in groups singing religious songs and offering prayers for marital bliss. Once the religious part of the festival is over, the Department of Tourism takes over to offer cultural evenings that culminate with an impressive display of fireworks.

In the small village of Chaksu, located close to Jaipur, the crowds gather in the month of Chaitra to worship Goddess Sheetla Mata. Stale food, cooked the night before, is offered to the goddess to pacify her, so that her wrath may be kept in check. The goddess is said to have miraculous powers that prevent smallpox. A temporary market is set up for the villagers who gather here, and devotees reach the venue using a great variety of transport — buses and jeeps, tractors, camel and bullock carts, and cycles and scooters. Community singing and dancing on the open grounds surrounding the hilltop temple is mandatory.

Chaitra is also the time for the Mallinath Fair of Tilwara held in the dry river-bed of river Luni in a village near Balotra. This is one of Rajasthan's earliest cattle fairs that lasts for a fortnight and attracts people from neighbouring states as well. An interesting fact here is that during the fifteen days of the fair, the underground water level of the Luni rises (said to be a blessing from Saint Mallinath), as a result of which there is enough water for the animals and the devotees gathered here.

The already festival-studded month of Chaitra has some more important religious fairs. The Kaila Devi Fair of Karauli, dedicated to Goddess Mahalaxmi, is held on the twelfth day of Chaitra Budi. The fair lasts for twelve days and attracts devotees from within and outside the state. For days, the roads leading to this small temple

Top: Jaipur is lit by millions of lights on the occasion of Diwali when people celebrate Lord Rama return to his capital with the bursting of fire crackers.
Above: At the stadium in Jaipur, kite flying competitions are staged on the occasion of Makar Sankranti, when the whole city skyline is a riot of colourful kites.
Right top: The horse riding skills of the warriors of Rajasthan is put to test at Chaksu Fair. The special breed of Marwari horses is known for its speed and agility.
Right: Dussehra offers a fiery spectacle, as can be seen here at Kota, when effigies of Ravana and his kins are put to torch in a splendid display of pyrotechnics. The devastation of the enemy, according to kshatriya or warrior tradition, provides the opportunity for celebration.

town are jammed with busloads of pilgrims making their way to the temple. Staunch devotees can be seen covering the distance on foot, and sometimes by lying prostrate on the ground and then pulling themselves forward, as if to measure the entire stretch to the temple with their body. Religious processions leave for the temple from nearby towns, singing devotional songs along the way.

Shri Mahavirji Fair is held to commemorate the twenty-fourth *tirthankara* (saint) of the Jains, Lord Mahavir. This is one of the largest Jain *melas* to be held in Rajasthan. Chandangaon in Sawai Madhopur district is the venue where thousands of Jain pilgrims congregate from as far away as West Bengal, Assam, Bihar and even south India. The image of Mahavirji, now installed in a shrine on Devta ka Tila, was buried deep underground and found by a cobbler ten centuries ago. During the fair, this image is carried in a golden chariot drawn by two bullocks to the banks of the river Gambhiri. Thousands of pilgrims escort the chariot to the river and back, singing devotional songs. The image is restored and the festivity continues with the special shops and recreation grounds that are set up especially for the visitors.

The temple dedicated to Karni Mata, the patron goddess of the rulers of Bikaner, is famous the world over for its rats that move around freely within its premises. Twice a year, in the month of March-April, and then again in September-October, devotees collect here to say special prayers. People gather in the temple premises to attend the *arti* as they join the priest in singing *bhajans*. Karni Mata was an ascetic who dedicated her life to the poor and the downtrodden. The fairs held here attract followers from all communities who gather to pay homage to this goddess. It is considered auspicious to see a white rat amongst the numerous brown rats.

Towards the end of March, the people of Rajasthan

gear themselves to face the coming summer. The months of Chaitra, Vaishaka and Jyestha fall in the months of April, May and June and mark the ending of Vasanta *ritu* or spring. This is the time when the weather starts getting warm and the number of traditional festivals begins to dwindle.

The scorching months of summer, when waves of sand blow over the land, is a time when both man and beast take shelter from the cruel heat. Any activity outside the house is kept to the minimum: it is a time for the people to recoup their energies for the months to follow.

This quarter has only two fairs — one traditional (the Banganga Fair, Bairath) and the other organised (Summer Festival, Mount Abu). On the full moon day of Vaishaka, people gather at the rivulet, 11 km from the ancient town of Bairath (also known as Viratnagar). The stream is believed to have been created by Arjuna, one of the mythic Pandava brothers who spent the thirteenth year of their exile in this region. There is also a two-hundred-year-old Radha Krishnaji temple here. This spot is considered holy by the pilgrims who first take a bath in the Banganga river and then pay homage at the temples and other holy sites.

In the month of Jyestha, which falls in June, the heat is at its peak and it is time to move to the state's only hill station — Mount Abu, which remains cool even when the rest of the state is reeling under the heat. The Summer Festival is organised by the Department of Tourism to attract more people to this area and provide them a glimpse of the tribal art and culture. Performances by folk artistes, and fireworks, are a highlight of this three-day event.

Soon after the hot summer months, it is time to welcome the most important season of all — the monsoon. Many of Rajasthan's folk songs and legends are connected with the rains. The months of Asadha, Shravana and Bhadrapada fall roughly in the months of July, August and September. The parched land takes on a fresh hue, and there is greenery, as well as a sense of joy: no wonder its arrival is celebrated with such vigour — after all, a good monsoon means a good crop. This is also the time for the farmers who have worked long hours on their fields to relax and enjoy the fruits of their labour. The harvest has been cut and the grain stored in their houses; there is a feeling of relief, of thanksgiving, and of rejuvenation.

This quarter's celebrations start with the advent of the monsoon month of Shravana (August). The parched land is ready to welcome the first drops of rain that will charge the atmosphere and bring the temperature down. Flowers are in full bloom, swings are hung from branches of green trees, and there is a spirit of joy. The third day (Teej) of Shravana is celebrated in a big way. The festival is dedicated to the union of Goddess Parvati and Lord Shiva. Women dress in green clothes and the traditional *lehariya*, which denotes the arrival of spring, and pray to the goddess for conjugal bliss. It is mainly a festival celebrated by women, and due importance is given to the womenfolk by the male members of the family. In rural areas, the festivities begin weeks before the main day of Teej. Women gather together and sing and dance, new clothes are purchased, traditional sweetmeats are made, and feasts organised. In other parts of Rajasthan, Teej is celebrated in a somewhat different manner but on the whole, the proceedings remain the same. In Bundi, Teej is celebrated on the third day of Bhadrapada.

Top: The tazias of Moharram, a Muslim event, are carried through Jaipur, marking the tolerance and respect that religious cultures have always enjoyed in the state.
Above: Participants race camels to vye for the prize. The camel, in Rajasthan, is truly a man's best friend, and has been bred to provide transport, plough the arid desert land, and provide the hide for use as soft leather.
Right above and below: The camel trading fair at Pushkar is the largest such event anywhere, and offers a spectacular scene of thousands of camels being bought and sold. For almost a week, villagers set camp, sleeping on the soft sand and cooking their meals over open fires. However, different regions in Rajasthan also have camel and cattle fairs at different points of the year.

Another important fair that falls on the ninth day in the month of Bhadrapada is held in a small village near Nohar in Hanumangarh district. It is devoted to the memory of a folk deity called Gogaji Veer, recognised popularly as the god of snakes. Revered by both Hindus and Muslims, the spot where Gogaji took *samadhi* is known as Goga Medi and every year thousands of devotees gather here to pay homage to the saint. The fair lasts for three days and attracts visitors from neighbouring states as well. There is a belief among the devotees that Gogaji can cure diseases. And many visitors are here to offer thanksgiving when their wishes are fulfilled.

In the same month, and around the same time, another folk deity is revered in Runicha, or Ramdevra, a small village near Pokaran. Baba Ramdevji or Ram Shah Peer was a fifteenth century saint who came from the Tomar Rajput clan. Widely believed to be an incarnation of Lord Krishna, Ramdevji was known for the miracles that he brought about to help the poor and the needy. In a fair that lasts for ten days, lakhs of devotees gather at Ramdevra to bathe in the Ramsar tank and pay homage at the shrine — the *samadhi* of Baba Ramdevji. At this religious fair, devotees spend most of their time singing devotional songs extolling the virtues of their revered saint. The saint's love for horses has led to devotees buying stuffed toy horses which are offered in the temple. An attraction at the fair is the performance of the *terah tali* dance by the members of the Kamad community. Two men relate the history of Ramdevji to the accompaniment of the four-stringed *tandoora*. Two women perform the *tera tali* dance which can go on throughout the night, and includes the acrobatic clashing of cymbals attached to the dancers' bodies.

Shishir and Sheetkal are happy months in Rajasthan as the people from the desert state are able to move outdoors and participate in the various fairs and festivals

that take place all over.

The months of Ashvin, Kartik and Margashirsa fall in October, November and December, marking the onset of colder weather. It is time for another round of celebrations. This quarter begins with the Marwar Festival held annually in Jodhpur in the month of Ashvina. Unlike the other traditional fairs, this one is specially organised in the memory of the heroes of Marwar. The period of full moon nights has always had a special significance in the Hindu calendar and Sharad Poornima is the time chosen for this festival. Its venue is the stately Umaid Bhawan Palace, and the folk dancers and singers provide a glimpse of the music of Marwar.

The Marwar Festival is followed on the tenth day of Kartik by Dussehra. Dedicated to the victory of Lord Rama over the demon king Ravana, festivities include the enacting of the Ramleela, a dance drama that retells the legendary battle between the two. Effigies of Ravana are burnt on the tenth day symbolising the victory of good over evil. Dussehra is parallel to a festival dedicated to Goddess Durga. The Navratri, or nine nights, commemorate the victory of the goddess over the demons.

The month of Kartik, which falls in November, is the time for Rajasthan's best known, and perhaps its most important fair — Pushkar. It is both a religious as well as a commercial event. Held in the sacred town of Pushkar, 11 km north-west of Ajmer, it is awaited eagerly not only by the local population but also by visitors from all over the world.

Every temple — and there are hundreds of them in Pushkar — and every *ghat* has a religious significance. The lake here finds mention in the ancient text of Padama Purana. It is believed to have been created by Lord Brahma himself who performed a *yagna* here and

While men are mostly concerned with the commercial aspect of Pushkar, the women who accompany them pray at the temples on the banks of Sarovar lake, gather to meet, talk, socialise, arrange matrimonial alliances, and shop to their heart's content.

sanctified the entire area. Devout Hindus believe that without a dip in this holy lake, their pilgrimage to the four main centres (*char dham*) is incomplete. A rare temple dedicated to Lord Brahma is also to be found in Pushkar.

Though there is a steady flow of pilgrims throughout the year, the month of Kartik has special significance. This is the time when lakhs of devotees converge on this small town and turn it into a bustling, crowded fair. The event that goes on for twelve days is also the venue for the annual cattle fair. An amazing number of camels, horses and livestock collect here as their owners participate in the trading. For visitors from outside the state, this fair provides a panorama of memorable visual images: the colours of Rajasthan, and the beautifully decorated animals against the equally breathtaking backdrop. The atmosphere is infectious and visitors find themselves drawn into the laughter, song and dance that is intimately associated with it.

Kartik is also the time for the annual Chandrabhaga Fair, held in Jhalraptan. The Chandrabhaga river is considered holy by the people of that region. They converge here on the full moon night of Kartik Poornima to take a dip and offer prayers at the temple at Chandrawati.

The full moon in the month of Kartik has a special religious significance and there are dozens of small religious fairs that take place in villages all over Rajasthan. Among others, the Kapil Muni fair at Kolayat near Bikaner is important. Kapil Muni is believed to have descended from Lord Brahma himself, and there is a belief amongst devotees that a single day spent in Kolayat is equivalent to ten years spent in other sacred spots. A beautifully located temple dedicated to Kapil Muni and the fifty-two

Above: A Kachi Ghodi dancer looks forward to an enactment of the performance of the bridegroom's procession.
Far left: Little children love to dress up on any occasion that will give them the liberty to wear their mothers' jewellery.

Left: Villagers gather in the courtyard of the castle in Mandawa to celebrate Gangaur. Once, it was here that the nobles would herald the start of a celebration at an auspicious time, and in many places the tradition has continued even in present times.
Below and bottom: Women play a prominent role in the celebration of festivals, adding colour not only with their clothes, but also through their participation in private soirees of music and dance.

shaded ghats allow the pilgrims ample place to bathe and pray.

The thirteenth day of Kartik is devoted to the festival of lights, and is celebrated all over the country as Deepawali, or Diwali. Dedicated to Lakshmi, the goddess of good fortune, the festival also dates back to the days of the Ramayana. When Lord Rama returned to Ayodhya after fourteen years in exile, the entire kingdom welcomed him by lighting up their houses. It is a tradition that is continued to this day. Each house, no matter how big or small, is lit up by hundreds of earthen *diyas*, candles and electric lights. Entire villages, towns and cities are bathed in a magical glow. The effect is overwhelming. Preparations for Diwali begin days before the actual festival. Houses are washed and cleaned, and sometimes even whitewashed and painted. People wait for this occasion to purchase new things for the house. Old, useless things are thrown out. Members of the family also buy new clothes. This festival also marks the beginning of the Hindu new year. For businessmen, it means the end of the financial year: old account books are closed and new ones opened after praying to Goddess Lakhsmi.

In Jaipur, there is an interesting legend connected with Diwali. The Kachchwahas usurped the kingdom of Amber from the Mina tribals on the night of Diwali. Dressed in black, and undetected in the darkness of the night, the usurpers attacked the unsuspecting Minas on this festive night. Ever since, Diwali has always been special for members of the Jaipur royal family. To commemorate their past, ladies from the royal family dress in black, a colour that is otherwise considered inauspicious.

Top: In the Braj region around Bharatpur, the playing of Holi involves beating each other up — more as a ritual than as violence — and its participants look forward to the event with evenings of song and dance a few days before the festival.
Above: Folk dances have a nuance and rhythm that is as old as the cultures from which it has emerged, and in which it remains ensconced.

Above and left: The spectacle of Rajasthani dances tends to be both vibrant and colourful, irrespective of whether it is men performing the Gair dance, or women gathered at the Garasiya fair at Mt Abu. In the end, it is their participation that is significant.

Another important festival is the Urs. Held during the first six days of Rajab (seventh month of the Islamic calendar), the holy city of Ajmer is the venue for the biggest Muslim fair in India. Thousands of devotees of Khwaja Mouinuddin Chishti gather to pay homage to this saint whose mortal remains are buried here. The saint came from Persia and established the Chishtia order of *fakirs* in India. Popularly known as Garib Nawaz, the Khwaja dedicated his life to the service of the poor. Emperor Akbar walked to the *dargah* on foot to pray for a son and on being granted his wish, he presented a huge cauldron that is still in use. Other Muslim shrines of importance where the devout gather, though on a somewhat smaller scale, are in Nagaur, Sambhar, Tala and Galiyakot.

These are just some of the more important fairs and festivals of Rajasthan — many more are held all over the state. Rakshabandhan, Ganesh Chaturthi, Basant Panchami, Janamashtmi, Muharram and a score of other equally important observances are associated with their own special functions and traditional celebrations. It is simple for a visitor to share the excitement and emotion that seems to drive the people at such times.

Top and above: Social commentators believe that the winds of change are sweeping over Rajasthan, though the villagers still seek their entertainment on giant wheels and merry-go-rounds, preferring them to more modern contraptions.
Right above and below: The Beneshwar fair is becoming known as an extremely colourful event, held annually at Dungarpur, also aimed at combining the religious and social with commercial transactions. Obviously it is the latter that attracts people who perch everywhere for a glimpse of the attractions.

RITUALS, CEREMONIES, RELIGION
A Matter of Faith

There are two silver urns placed prominently in the City Palace in Jaipur. Visitors often express themselves puzzled by their presence, particularly since the attendants are quick to point out that these are the largest silver objects in the world, as recorded in the Guinness Book of World Records. But more interesting is the reason these urns — there were three altogether, but one has since been lost — came to be made. According to Hindu belief, crossing the seas to journey to distant lands inhabited by heathen races was an act so unholy, it brought upon the perpetrator untold calamities. Not content with that, it was deemed that the contaminated person would also lose his caste in the Indian social context.

Till such time as travel remained in the realm of the impossible, this suited everybody just fine, but with increased interaction with the British in India, and the regular plying of the P&O liners to Mumbai, the temptation to travel to England and other pockets of Europe became too strong to resist. Sometimes, of course, travel was necessitated by the demands of the office: a war had to be fought in distant Haifa, or a treaty signed in Versailles.

When the Maharaja of Jaipur expressed his desire to travel to London, the consternation in his court was managed somewhat with the thought that he would bathe with water carried from the river Ganga, and dine on food cooked by his accompanying chefs who would use the same 'Indian' water for their culinary preparations.

The large silver urns served their maharaja well, but left no one in doubt about the seriousness with which the people of Rajasthan took their rituals. A martial race, they went to the battlefields with their gold amulets and damascened swords to kill and be killed: but equally obligatory was their visit to their temples where they paid obeisance before their gods and goddesses. If they were killed, their wives committed *jauhar*, the mass leap into funeral pyres which, we are informed by the state's bards who still sing of such trials, was conducted with dignity, and in the nature of a celebration. Difficult to believe? Perhaps, but the voluntary imprints left behind by their tiny hands at the entrance walls of forts before they came to their fiery end, tell a somewhat different tale. The honour of a fort, we are again informed by the same minstrels, lay not in remaining unconquered, but in the number of such handprints collected at its entrance gate.

For a people who rewrote history with a flick of their wrist, the Rajputs proved to be extremely religious as a race. But then, not surprisingly, they claimed the gods as their ancestors too. State chroniclers traced the history of each of the Rajput clans back to the gods and the elements. The Suryavanshi Rajputs were descended from Rama, the hero whose exploits fill the epic Ramayana, while the Chandravanshi Rajputs trace their lineage to Krishna, the prank-loving god who is a central figure in the other great Indian epic, the Mahabharata. Both, needless to say, were also kings. For those who could claim neither, a third category was the Agnikul, or fire-born.

But the people worshipped, besides Rama and Krishna, also Shiva and his manifestations, especially in the female form of the Devi whose incarnations as saints led to the creation of family deities who were ensconced in temples where the families came to worship. Maharaja Ganga Singh of Bikaner would walk barefeet from his capital to Deshnoke where at the shrine of Karni Mata, he would pray for the success of his ventures. No war was fought, no major task or journey undertaken, without the ritual worship of the family deity. Such faith was abiding: Karni Mata, after all, had predicted to the founder of the Bikaner dynasty of Rathores that he would be successful in laying the foundations of a new kingdom. Maharaja Man Singh of Amber, on the other hand, carried an image of Shila Devi all the way from Jessore in Bengal, and had it consecrated at the Amber temple. And the Maharanas of Udaipur, who offered protection to the Vallabhachari sect fleeing from Muslim oppression, pay homage to the idol of Krishna as Shrinathji at Nathdwara. According to the tale, apocryphal or otherwise, the chariot carrying the particular idol of Krishna got stuck at Nathdwara and no one was able to get the wheel unstuck. Taking it as divine intervention, it was decided that it was here the idol would be consecrated, and so Nathdwara came to be a pilgrimage centre.

It is in these and multitudes of other temples that the

Left: Even stones daubed with vermilion can become symbols of religious significance, with people offering water and flowers in simple ceremonies. For most people, it is their faith and belief that is the underlying current of their lives.
Below: Women collecting to pray hold a platter in their hands containing the few objects with which they venerate their gods.

people continue to come when they are wed, and when they are blessed with an heir, when there are festivities, or during the ritual nine days of fasting during Navratri; they come here when they wish to ask for something, and to pray when their wishes are fulfilled. They come on pilgrimage, or merely to complain to their gods who are also their ancestors. It links them intimately with their gods, and reverence is also shared with a feeling of kinship. In the hard wastelands of the desert, such faith is healing.

Religion has a very strong hold over the people of the region. Nor is the tradition of the gods as kinsmen merely an ancient one, for there is evidence of many of their saints as living beings who created a following for themselves through miracles and oracles. The Bhatis of Jaisalmer claim that it was decreed by Krishna that one of his followers would establish his kingdom at Trikuta hill, while Kapil Muni, one of the saints mentioned in the texts of the ancient Vedas, is believed to have worshipped at the lake at Kolayat, a pilgrimage centre close to Bikaner, with its banks bursting with temples.

Mysticism took on many forms, and included all the principal forms of Hindu worship: Shaivism, or the worship of Shiva, as well as Vaishnavism or the worship of the incarnations of Vishnu, prominent among these being Krishna and Rama. So strong were their beliefs, that the gods took on human attributes and Princess Meerabai of Chittaurgarh refused to consider her marriage because she claimed to have married an idol of Krishna in her childhood. Her mystical poetry is submerged in romantic longing for her lord, and even centuries later, remains popular.

It wasn't, however, only the gods that the people worshipped. Though they put their women behind *purdah*, there was a strong tradition of worship of female principles or mother goddesses, a cult common to all ancient civilisations. They thought little of bowing their heads before Saraswati, Lakshmi and Kali, the

consorts of the all-powerful trinity Brahma, Vishnu and Shiva. In particular, the Shakti cult, represented by Kali, whose benign form is Parvati, with a symbiosis of cosmic energy, pervaded. Each family has its tutelary deity, a manifestation of Jagdamba or the universal mother, as represented by Devi.

It is no coincidence that the foundations for forts were cast by horoscope, and their sites were usually dictated by living saints with mystical powers. The establishment of a temple was therefore ritual, and often preceded the building of the fort itself, and sometimes outlived it too. Chittaurgarh, for example, may have been abandoned centuries ago, as was Kumbhalgarh, but there are temples within their fortifications where the bells still peal and the people gather to pray, or leave behind offerings.

There are scatterings of temples all over the state, some in groups such as at Osiyan, others more resplendently alone within their own fortifications. Their architecture is typically medieval with the prescribed manner of sanctum sanctorum fronted by an assembly hall and surrounded by a perambulatory. They are on a high plinth with steps leading to a portico before gaining entry to the main hall, sometimes preceded by a smaller hall. Sculptures of deities and floral arabesques are carved on the facade, and into the ceilings. In the Shekhawati region, the temple walls, and particularly their ceilings, are also painted with images from the epics.

However, when it comes to splendour in temple architecture, it is the Jain temples in Ranakpur and Mount Abu that spring to mind. Created by the Jain community that believes, otherwise, in great austerity, the marble temples are so extravagantly carved with images of deities, celestial beings, animal figures, and floral and geometric motifs, that there is literally an embarrassment of riches.

The Jains were prominent merchants and traders who served at the Rajput courts and whose influence in political matters was considerable. That this may have been because they also served as money-lenders to the kings is, of course, not inconceivable. The Jains believe in a continuous cycle of life and rebirth, and so have no supreme being to whom they pray. Instead, the Jains have 24 *tirthankaras* or ford makers, or more simply those who help people move from one stage of rebirth to the next: it is their images that are usually enshrined within the temples. These idols are often depicted nude, and their is a great rigidity to their body postures, which is at odds with the relaxed forms of Hindu iconography.

All over Rajasthan and the neighbouring state of Gujarat there are magnificent examples of their temple architecture (the only place where the Jains have exhibited a similar exuberance in their residential architecture is in Jaisalmer). At both Ranakpur, and in the Dilwara

Top: No auspicious event is complete without the obligatory tilak or vermilion mark on the forehead in the presence of the gods, made either by a priest or by the women of the family.
Above: A woman rings a bell at a temple that is probably located on the periphery of a village. The colours of her dress mark her as a woman who has provided a male heir for the family.

Top: The actual wedding ceremony, held after sundown, has the bride with her face veiled, while her groom sits beside her preparatory to taking seven rounds of the holy fire that sanctify their union. The marriage is solemnised by a priest in the presence of the bride's parents, though the groom's parents do not watch the ceremony.
Above: No wedding, or indeed auspicious occasion, is complete without the mehndi or henna women use to decorate their palms. The dark green leaf paste leaves behind a distinct orange colour when the dried pattern is washed off.
Following page: When the people of Rajasthan gather to celebrate their many festivals, it is difficult to make out who is the more colourful of the two: the men with their vibrant turbans, or the women in their multi-coloured mantles. In the colours the women wear, or the manner in which the men tie their turbans, one can find their complete sociological histories.

complex in Mount Abu, there are groups of temples: here, pillars, arches, ceilings, facades, every available space is so profusely carved that it dazzles the eye.

The only comparable Hindu shrine is one on account of spectacle rather than splendour. At Pushkar, close to Ajmer, thousands and thousands of pilgrims gather in November in a cycle that must be as old as the Jain cycle of births and rebirths. At least, no one knows just how old the Pushkar *mela* or fair is, but if accounts are to be believed, it is as old as mankind itself. At the heart of the fair is a temple to Brahma who was cursed that he would not be propitiated on earth. Eventually he did merit two temples for himself, of which Pushkar is extremely popular. It is a coincidence that the camel fair here occurs at the same time as the holy full moon night when it is considered auspicious to bathe in the holy pond, and then pray at the temple. For miles all around, all one can see is a vast sea of colourfully garbed people, the silhouettes of camels visible over their heads, and the trail of smoke from hundreds of campfires is a scene that is reminiscent of Biblical times.

The association of religion with commerce is particularly close in Rajasthan where most camel and cattle fairs are associated with places and dates that coincide with worship at nearby shrines. And on these occasions, faith does not come in the way of different religious communities. Not strangely, then, at the Muslim shrine at Ajmer, it is not uncommon to find Hindus come to pray at one of the most prominent sites of Muslim pilgrimage in the country.

The shrine of Khwaja Moinuddin Chishti has always enjoyed renown but it was the Mughals who gave it elevated status when they chose to come here on their pilgrimages, and to seek the blessings of an heir. At the annual Urs festival, pilgrims throng to the shrine for their share of the saint's blessings and consecrated food that

is cooked piping hot in giant cauldrons in the courtyard. But this is by no means the only Muslim shrine of renown, others including one at Kota, and another at Sikar which is all of eight hundred years old.

There are popular folk heroes too who are propitiated by the people of the state, and these include Ramdeoji of Runicha (near Pokaran) who was known to heal incurable diseases; Pabuji who helped break barriers between different castes by sharing their food; Gogaji of Gogamedi (near Ganganagar) who had the power to heal snake bites; and Mehaji and his son Harbhuji who gave up their lives while protecting their village community. Not only do people come to worship at their shrines, they also remember them with affection in the form of folk ballads and performances.

A protective aspect of Shiva that is popular is as Bhaironji, and there are several shrines to this manifestation. It is here that people bring their new born infants for their first haircuts, known as *jhadula*. Following their haircut, the children are formally placed in the protection of the family deity. Rites such as these, it is believed, ward off misfortune, illness and enemies, and help to bring in the desired wealth, success, marital bliss, and even heirs to continue one's lineage.

A Rajasthani and his gods are never far removed: at the entrance to their homes are images of Ganesh; at the entrance to forts, you'll find vermilion daubed idols of Hanuman; and at Deshnoke, even the rats in the temple are considered sacred since they are believed to be the souls of the Charans (bards) who have served at the

Top: A sadhu or religious mendicant tends to people's faith at the Gayatri Mandir, Pushkar. Such people have guided the villagers through trying times simply by offering them continuity and hope in their beliefs.
Above: Women undergo the solah-sringar, the sixteen ways of making themselves beautiful, in preparation of worshipping the idols of Shiva and Parvati on the occasion of Gangaur.
Right: Even the simplest stone slabs in Rajasthan can carry a great deal of significance for the people, since they mark the presence of gods and folk heroes, or even spots where their warriors may have fallen in battle.

shrine of Karni Mata. And the Bishnois, who not only protect but also worship animals and trees, do not allow their killing, at least on their land.

The desert is ancient, but compared to the seas that once flowed here, it is, of course, younger. Ancient civilizations such as that of the Indus Valley, which once spread in these parts, have long since gone, disappeared forever but for the remains being excavated by archaeologists. The immediate history of the land is much, much more recent. The warriors who came to rule their vast desert kingdoms came from other parts of India, leaving behind kingdoms they had lost or had to abandon. The desert towards which they made their way, and the Aravalli hills that offered them shelter, were the homes of tribes such as the Minas and the Bhils. Here, the Rajputs established new dynasties, but the support of these tribes was crucial to their survival. Therefore, the consecration of a new king was usually an elaborate ceremony conducted in their presence.

In Jaipur, the *tilak* or auspicious mark on the forehead of the king may be that of a Brahmin's, but in Bikaner the honour rests with a clansman of the Godaras; in Udaipur, blood, not colour, was used for the ritual. These are ceremonies, seemingly meaningless in today's times when the princes have been derecognised, but they are still held. And on their birthdays, the maharajas are still honoured by a gathering of their clansmen. Whether in Udaipur or Jaipur or Kishangarh, but more particularly so in Jodhpur, the maharaja receives *nazar*, or tribute, from his former clansmen and aristocrats in a

The simple faith of the people is absolute, whether it is women who worship their idols, or men who pray before them, for most part treating their gods as an extension of their selves, in the form of their ancestors.
Right: In a land where the elements can be hostile, even trees are objects of deification, particularly the peepul tree, which is worshipped on special occasions, as well as in the mornings, by women.

formal *durbar* where attendance is strictly by rank. In the *zenana* wing of their palatial residence, the erstwhile maharani hosts a women's *durbar*, and here the head of the family is invited to watch the women perform the *ghoomar*.

Nazar was an important aspect of the erstwhile court where everyone from visiting nobles and heads of state to heads of different communities and craft guilds offered tribute, a sum that was normally specified in advance, and intended for the kingdom's treasury. Personal tributes, on the other hand, were usually doubled by the maharaja and returned by him as a token of affection.

In their birthday courts, or on other ceremonial occasions, it is time once again to sport their traditional regalia. Sometimes these are *achkans*, long tunics, with gold buttons down the front, and a jaunty turban on the head. They may wear the only slightly less formal *bund-gulla* coats, or what are known as prince coats, *with their jodhpurs*, riding breeches that also originated from the polo-playing, horse riding community of Marwar.

In Jodhpur, as in the Bishnoi community, visitors were welcomed till recently with a ritual offering of opium. This could not be spurned as the maharaja would otherwise take it as a mark of disrespect, but it was not without its dangers. History is rife with examples of how the maharajas used the device to rid themselves of inconvenient ministers, while it was not without its lighter moments: a maharaja commanding his courtiers to give his uncle '*dooni*' or twice as much, found the next day that it had been interpreted in the official records as the grant of a village named Dooni.

Opium, however, has not been unknown in the desert where it has been used as a soporific for everything from drugging a child who is unwell to opiating soldiers before they rushed out to war. In the latter case, it may have provided the warrior a numbing resistance to pains caused by battle wounds.

They propitiated their gods and they faced death valiantly, but the Rajputs also knew how to live life to its

Rituals mark every stage of one's life, whether one's betrothal or marriage, or the first offering of a child's hair to the gods to seek their protection. Such ceremonies are usually conducted by family priests, and often involves the havana or fire ceremony to sanctify the observance.
Right: The Udaipur maharanas, with their ancient lineage, have always been considered as the first family of Rajputana. Here, Maharana Arvind Singh, also called Shriji, participates in the Dussehra ceremony.
Following page: The shrine of Galtaji nestles close to the fort of Amber, and has a wide following. On special occasions, people take a dip in the pond before offering worship at the sanctum sanctorum.

hilt, though even here, ritual was a binding force. The colours they wore, for example, or the manner in which they tied their turbans, explained more than anything else, the community, region and marital status of the wearer. Unlike other parts of the world, for example, the colour of widowhood is not black, but a deathly brown, though pale greens and blues are also in prevalence; and a man wears a white turban only on the death of his king, or his father, in whose honour he also shaves off his hair. At all other times, yellows and reds and oranges, aquamarines, deep blues, vivid pinks are the chosen colours, livened up with the use of lame ribbons and gold embroidery. These are sometimes worn according to the season, but one particular colour, a combination of yellow and red, is a privilege reserved only for married women who have produced a male heir. The bold imagery, of the red dot dyed against the otherwise yellow field of the mantle, itself is a symbol of a broken maidenhood.

While the tradition of wearing turbans in cities has begun to wear off, it is still prevalent in the villages and small towns. There, to appear without a turban on one's head is considered a mark of disrespect. When a feudatory chief wished to surrender before another, he would send his turban as a tribute. If it was accepted (and later placed back on the head of the vanquished), it was deemed that the one had accepted the subservience of the other. If it was rejected, the battle would continue. Exchanging turbans was a sign of friendship. Since ornaments were worn over turbans on ceremonial occasions, sometimes the exchange of turbans was merely a device to acquire a particular turban ornament that one coveted.

Nowhere else in India has *purdah* survived to the extent it has in Rajasthan. Literally the veil, married women cover their heads with their mantle, and veil it from the gaze of the elders in the family. Sometimes they must also veil their faces from those women in the family deemed worthy of similar respect. While there is a gradual relaxing in these rituals, till recently it was unseemly for women to be seen in public. In villages, therefore, they could walk from one house to another only if escorted by children carrying sheets (or curtains) of cloth on either side to conceal them from masculine gaze. In palaces, curtains would be pulled around porticos when the *zenana* women wanted to get into or out of cars. It is also the reason why most palaces and *havelis* have separate wings, called the *zenana*, where the women would reside, and go about their chores. Their interaction with the outside world was usually limited to gazing out of the windows of their apartments from behind the privacy afforded by pierced screens. It is for just this reason that the Hawa Mahal in Jaipur was used, allowing the royal ladies to look out on to processions and other entertainments without themselves being seen.

Questions are often asked about the number of women a maharaja, and to a lesser extent the *thikana* or aristocratic heads, could marry. However, the Rajasthani *zenana* was unlike the popular concept of a harem. A king usually only had one principal consort who was wed on the understanding that the sons borne of her would have claim to the throne. However, in the event that she was unable to give birth to a male heir, the lineage would pass on to a wife next on the scale of

The temples of Ranakpur with their fine carvings are a testimony to the Jain faith. The Jain rituals tend to be austere, and even ceremonies organised at these temples are linked with the need to contain expenses, in splendid contrast to the exuberance of the temples themselves.
Right: Religious processions still mark a large number of festive occasions, especially those which were supported by the princely order and associated with the heroic tales of their own clans.

succession. As for the other 'marriages', these were usually alliances arranged between families as a token of fealty, and were used to seal treaties and bonds. Such brides could be very old or very young, and many never even had contact with the man they married. They usually came accompanied by their attendants who would take care of them, and their life was lived within the confines of the *zenana*. But a *zenana* was never without its intrigue, and since future heirs spent their early years here, a certain amount of power play came to be associated with this wing of the palace.

The birth of a male child, for which an accurate horoscope had to be cast, was celebrated by the 'ringing' of silver *thaals*, a tradition that has remained: the banging of a *thaali* from a rooftop and the offering of jaggery still denotes that the family has been blessed with a boy. The birth of a girl, on the other hand, is more discretely announced, and is still considered somewhat less a cause for celebration. This has its reasons, not all of which are historical: poverty, and the inability to provide sufficient dowry being one among many.

The Rajput may begin his day with prayers, and end the evening with it, but his piety is closely linked with his martial nature. Not then offerings of sweetmeats for his gods; instead, and particularly in the nine days of fasting that precede the festival of Dussehra, he sacrifices goats, beheading them with one blow of his sword, their flesh then consecrated as sacred food. When he sits down with his drink in the evening, he makes a ritual offering of it first, again, to his gods. Meals are eaten not from individual plates but in large platters around which sit members of the family, or clansmen, sharing the same food. Once upon a time, each meal would have been first fed to a food taster to ensure that it was not poisoned, for fratricide and patricide were not uncommon. Today, people still sit down for a meal together, served on a low, octagonal table called the *bajot*, while they sit on the floor around it. Hierarchy comes into play here too: while members of the royal families eat off *thaals* made of gold, and the aristocrats make do with silver, those lower down the pecking order may have to settle for anything from bronze to copper and, these days, steel.

Before partaking of the meal, each diner offers everyone else around the table a bite each, and at particularly large gatherings, this can mean that you are satiated before you have even begun to eat your meal!

Rituals continue to be followed in several other ways in today's society as well. Just as it is the maternal uncle who must gift his sister the *peeliya poshak* on the birth of a male infant, so too it is deemed his responsibility to carry for his sister's children, gifts from her maternal family. A wife, in turn, must send gifts of *ghevar* and a new dress to her husband's family, principally the wives of his brothers. These devices were intended to, and have managed, to continue to knit bonds within families.

Marriages are another occasion for families to get together. Marriages never occur between the same clan, which is why a Sisodia, for example, may have to marry a Chauhan, or a Rathore, or a Shekhawat. Once the alliance has been established, and a date set for the

Right above: Muslims offer their prayers in Jaipur, opposite the Hawa Mahal.
Right: Offering chadars or cloths at the tomb of Khwaja Moinuddin Chishti at the annual Urs festival in Ajmer. The dargah or mosque is considered among the holiest spots for Muslims in the subcontinent.
Far right: Sanctified food being prepared in a huge cauldron at the dargah in Ajmer.

wedding, the groom's family sends to the bride's the wedding dress and the '*aar*' necklace she must wear for the actual ceremony round the fire. During the wedding, the bride's face is kept veiled. While it is traditional to take one's marriage vows by walking round the holy fire seven times, there is a case too of only five such rounds being acceptable because, or so goes another tale, a prince was called to the battle in the midst of his wedding ceremony. Having finished only five rounds, but in a haste to go to the battlefield, he left, but was unfortunately killed. His bride, not still married, immolated herself on his funeral pyre, and ever since, five rounds have become acceptable among those particular clansmen.

A Rajasthani wedding is a spectacular affair, but only one person from the groom's side is actually permitted within the courtyard of the bride's family where the actual wedding takes place. He crosses the threshold of the house after striking the entrance with his sword,

a reminder that once the men made off with their brides after winning them through swordsmanship. As for the rest of the guests who form the *barat* or procession that accompanies the groom to the bride's home, they are entertained outside with dancers, and a feast is spread for them. Once, of course, these celebrations at a bride's house would last for weeks, if not months, but in recent decades this has shrunk to a few obligatory days.

The people of the state greet each other with a show of obsequiousness. They bow deep and say '*Khamaghani*' when they meet or depart, folding their hands in respect as they do so. While '*Khamaghani*' is an expression used between equals, it is not unusual for others to wish each other '*Jai mata ji ri*', literally: May the blessings of the goddess be with you. It is a greeting that is heartfelt: the goddess, after all, is a kinsperson too.

No celebration is complete without the participation of people who look forward, even preparing for them, months in advance. Such observances create a social pattern that links them as clansmen and communities, and highlights their inter-dependence on each other.
Opposite page: At the focus of the Pushkar fair is the Brahma temple, and people gather here to offer prayers to the divinity before they join in the social festivities that have an equally strong significance at this annual outing.

FOLK MUSIC, DANCES
AND PERFORMING ARTS
Rhythm and Resonance

Rajasthan's folk music, dances and performing arts reflect the Indian way of life which bases itself on a composite view of things. The cosmos, the environment, the weather; one's beliefs and traditions; and life and death itself: every philosophical, spiritual and physical plane merges into the cultural expression to shape an entity that continues to remain alive and vibrant. The state's geographical boundaries touch those of Punjab, Haryana, Madhya Pradesh, Gujarat and Uttar Pradesh in India, and Sindh in Pakistan. It is hardly surprising that the varied cultural segments of its neighbours have combined imperceptibly into the music and dance of Rajasthan to enrich it. Rajasthan represents that vital reality of the Indian way of life where the past exists and lives in the present.

In the villages of Rajasthan, as in other parts of India, the people base their festive calendar on the movement of the moon. Their music, songs, dances and associated festivals are all nature-bound: celebrating the elements and the environment around them.

In this arid zone, it is natural that the season of the rains is celebrated with rather more zest than most. In the rich repertoire of Rajasthani songs, even birds find a reference as friends and messengers. The peacock and the crow inspire village bards to create songs that epitomise romance. Similarly, the vegetation, the trees, the sun, the moon, and the clouds have become folk idioms that are used to express everything from the loneliness of a young beloved pining for her lover, their union, inter-personal relationships, laughter, faith and happiness.

The extensive variety of folk songs come under many categories: there are those sung by women, such as *Panihari,* that describes the daily chores of fetching water from the well and a chance encounter with the beloved who comes riding on a camel. Still another song, *Dal badli ro pani,* expresses the preoccupation of a village belle with water which, in the desert, is such a rare commodity. No wonder water has acquired myriads of creative connotations in imagery as expressed in the folk songs of Rajasthan. And in *Chirmi,* a plant becomes the friend to the young child bride who uses it as a confidante for her nostalgic emotions. In the myriads of other songs sung by women on the birth of a child, or on the occasion of a marriage in the family, familial relationships form an important part.

Strong religious beliefs in turn have given rise to songs dedicated to family deities, gods and goddesses. There are religious songs in the folk idiom, as well as those composed by saint poets such as Surdas, Kabirdas, Meerabai, Malukdas, and Dadu. These songs are heard at *ratijagas,* the night-long soirees of devotional songs which sometimes induce a trance-like spiritual milieu. In this particular cultural aspect of music, the division between classical and folk music begins to blur — the same devotional songs, as sung by village folk singers, form a vocal as well as a dance accompaniment to the classical form when sung by a classical singer.

The Jasnathi Siddhas tribe of the Thar are followers of Guru Gorakhnath who was famous for his yogic feats. Even today, they perform an amazing fire dance to the accompaniment of devotional songs, drums and pipes which reaches a climactic high with devotees dancing on a bed of live coals. In the same vein are the Nath Jogis of Rajasthan who, as mendicant singers, play the *jogia sarangi* to provide musical accompaniment to their singing. The Nath Jogis also carry a *chimta,* literally fire

Above: The Kalbeliyas belong to the community of snake dancers, and their mesmeric performances have hypnotised audiences all over the world. The dancers bend their bodies as they sway, appearing, at moments, seemingly without a spine.
Left: Most Kalbeliya dancers wear their characteristic black skirts with silver ribbons embroidered over them, though they may sometimes opt for less dramatic but more colourful clothing, as in this case.
Far left: Bhopas use the ravanhatha to help them sing of Pabuji's trials, using a painted scroll to point out relevant incidents from his life. They are assisted in their performances by their wives, called Bhopis.

tongs, which they clack rhythmically to create a musical beat. These Jogis are venerated for their knowledge of herbal medicines and the villagers place great faith in their prescriptions.

Other songs cannot be as easily categorised, but such favourites as *Endooni, Morubai, Diggipuri ka raja,* and *Dhola dhol majira baje re* are sung at homes, at community get-togethers, and, of course, on the occasion of festivals and fairs. Popular tunes such as those of *Panihari* and *Dhola...* have been included in the repertoire of army bands. It is not unusual to see colourfully attired young men and women en route to a village fair break into these songs, and an endearing sight is of a bunch of young women on a tractor being driven by a dandy while singing *Diggipuri ka raja.*

The musical tradition of Rajasthan includes its unique entertainer tribes — the Langas, Manganiyars, Mirasis, and Dholis, to name only a few, are retainers of a tradition that has no parallel in the world. Some singers from these communities are well initiated into the nuances of classical music, though their idiom remains folk in nature. Their education in music begins early in life, and the art is passed on naturally from father to son. It is a routine sight in a Langa or Manganiyar family to see a grandfather sitting cross-legged with his five-year old grandson while prompting him into the intricacies of a *raga*. These entertainer communities have survived on a social system of patronage provided by land-owning agriculturists, business families, and the royal clans. Each family of singers has its designated *jajmans* or ancestral patrons at whose homes these artistes congregate to celebrate births, marriages, a child's naming ceremony, or other festive occasions.

The entertainers often make their own instruments, whether it is the simple *daf, dholak or ektara*, or more complicated ones such as the *kamayacha, sindhi sarangi, ravanhattha, jantar, surnai, flute, bankia, or algoja*, calling for their ingenuity in the use of their somewhat limited resources: goatskin, guts, metal strings, hollowed gourd, and wood.

While the Langas and Manganiyars of the Marwar region (around Jodhpur) could form the subject for an anthropological and environmental study, there are certain characteristics that even the amateur music lover cannot fail to notice about them. These musicians form a precious link between the classical and the folk, what in technical terminology would be called the Margi and Deshi music of the land. Most of them are masters at delineating melodies in *rag-raginis* while sometimes remaining unaware of the grammar. They also have the musical prowess to switch over from one scale to another effortlessly while maintaining tonal and notational variations.

Such folk singers begin with an *alaap* which is use to elaborate the form of a melody, and then recite a couplet called *dooha* which sets the tone of the song to follow. The song itself is a veritable combination of *taans, tihais* (triplets) and a variation of rhythms. A musical concert by the Langas or the Manganiyars is a complete experience in poetry, vocal music and expertise in instrumental music, along with a mastery of rhythms. In such a concert, eight to ten musicians combine to play the *kamayacha, sindhi sarangi, matka, khadtaal* and *morchang*. As expert singers, they take their cue from the lead singer and follow a code that is best understood in the context of their own community. In spite of the fact that most of them are uneducated and

Above: Folk musicians at a performance at the Sam sand dunes of Jaisalmer display their repertoire of instruments that includes the matka, a simple terracotta pot that is drummed using one's fingers to create a frenetic beat.
Left: The Gair dance of Mewar uses the beat of the sticks the men hold in their hands to provide them the tempo to which they move in clockwise and anti-clockwise movements.
Far left: At a private performance in the desert, these musicians use the algoja which is played with the help of one's teeth, and the khadtaal, which resembles cymbals, to support the harmonium and the dholak, both of which are better known instruments throughout India.

unlettered, their oral tradition has a strong following.

The Bhopas form another traditional community of singers, and are equally well initiated into the intricacies of music handed down to them by their forefathers. They are singing minstrels who tell of the sagas of bravery of local heroes who have since been deified. Those singing the Bagadawat belong to the community of Gujjars or Kumbhars, the Kamads sing of Baba Ramdeo, while the Thoris and Nayaks sing the saga of Pabuji. They wear a red gown, a turban and a waist band. A scroll painted by the Cheenpas or Joshis (communities specifically known for this particular type of stylised painting) consists of a cloth about six metres in length and two metres in width. It is over this that the life span and sacrificial deeds of the regional hero are painted.

The Bhopas travel from one village to another, and their arrival at a particular destination is heralded with invitations from various families who, then, proceed to also invite the village to come and observe their performance. The Bhopa unrolls his pictorial scroll and positions it with the help of bamboos. Then the balladeer, who has his wife, the Bhopi, with him, blows the sacred conch to indicate the opening of the story. As the Bhopa sings the narration, using the stringed *ravanhattha* as accompaniment, the Bhopi illuminates those parts of the scroll which are being described, and also pitches in as a singer.

The ballad of Pabuji, the Bagdawat, Ramdeoji's saga, Gogaji and Tejaji's heroic tales, are sung in Rajasthan by different communities. Performers use the following musical instruments: *jantar, manjeera, algoja, damru, dhol, kansi ka kachola*, and *ektara*. The soft jingle of bells, the music of various instruments, the glow of the oil lamp illuminating parts of the colourful scroll, and the melodic voices narrating the romantic, heroic, sad, but nevertheless inspiring tales of these heroes constitute a spectacle that continues to fascinate audiences.

The folk dances of Rajasthan too are inextricably woven with their folk songs. Like the songs, the dances too have categories, and some are specially intended for social celebrations like marriages, while others are specifically associated with festivals like Holi. There are also dances for religious occasions such as the *terah taali* which is performed by the Kamad community before an image of the deity. Festivals provide an occasion for the community rituals of music and dance.

On the first, third, fifth, eleventh and fifteenth day of the waning or ascending moon, there are festivities to celebrate nature's bounties. Beginning with January, when Makar Sankranti is celebrated throughout the region, the festive spirit is ignited with people coming outdoors to fly kites, and cook elaborate meals using the season's new grains. Following a series of celebrations, it is time for the spring festival of Holi in March. Over the centuries, different regions of the desert have evolved a

Dholis refers, in general, to the singers whose performances mark all festive and auspicious occasions. Well versed in their tradition of folk singing, several of them also know the nuances of the classical note and beat.

Whatever the instrument, it is usual for men to play them before an audience. The performers bring as much versatility to bear on their music as on the instruments themselves, made from the limited resources the desert puts at their command.

variety of Holi dances, most associated with myths linking Krishna with the colourful celebrations. In folk songs, references to Krishna and Radha keep cropping up. In one particular song, *Phalgun aayo*, Radha entreats Krishna to get her a saree that will match all the colours of Holi. Human emotions are closely associated with the songs and dances of Holi.

Fifteen days before Holi, ritual dances begin in almost all regions of Rajasthan. The Dhap dance is one such by men who hold the *chang* (tambourine) and play it to keep the rhythm going. They also use it as a prop while they jump and posture 'around' it.

The Gair is a dance from the regions of Marwar danced exclusively by men who at times wear long, flowing robes with a colourful waist band. They hold long, decorated sticks with bells attached to them. A circle is formed with alternate members facing outwards. The dance starts with an anti-clockwise movement with dancers pairing once to one side, and then the other. There is a lot of pirouetting to the accompaniment of the beating of drums. As the tempo builds up, the dancing feet become nimbler and the musical tempo of the *surnai* and *nagada* builds up a high crescendo.

The Raas Mandal is somewhat similar to this, and is performed in the regions of Bharatpur and Karauli. Since these towns are adjacent to Lord Krishna's birthplace (Braj), the Holi 'Raas' is performed here with a religious fervour that is coloured by a spirit of love, naughtiness, and teasing. The Raas Mandal songs describe episodes from Krishna's life. The dancers move in a circle that keeps changing its formation, the dancers gradually entering into a state of abandonment. The all-male dancers improvise the roles of Krishna and the *gopis*. An air of revelry prevails, and witnessing the dance, one cannot help thinking of the cosmic dance of the planets, the cycle of the weather, and the earth itself in motion. The Raas Mandal continues over several nights till the arrival of the festival of Holi.

The noted scholar Dr. Kapila Vatsyayana has dealt upon the notion of the 'circle' in Indian folk dances in her book 'Traditions of Indian Folk Dance', drawing a lucid parallel between the classic and the philosophical concept of the universe as a circle moving and mutating gradually. This philosophical notion finds a simplified expression in the folk dances that base themselves on the formation of the 'circle'.

The Ghoomar dance of Rajasthan has now become synonymous with the state. A sophisticated version of Ghoomar is performed during the festivals of Gangaur

Above: Kalbeliya dancers perform before a private audience in the splendid Durbar Hall of Samode Palace, an assembly room that is a fitting background with its exquisite frescos. Left: A Terah-taali dancer sits down to perform before an image of her deity who is propitiated using thirteen cymbals to create a crescendo of music by the dancer herself. Right: The use of puppets to enact tales from the past, or recount the scriptures, and now even social commentary, has a long and hoary tradition in Rajasthan.

Chari dancers whirl before an audience, hypnotising many with the flames that dance in the brass pots they balance on their heads.

89

and Teej. Initially, Ghoomar is said to have been performed by the ladies of the royal families within their inner courtyards on any festive occasion. This dance too has the same 'mandala' or circular formation. The Ghoomar as danced in the urban centres of Rajasthan, has gentle movements using the hands, and lilting waist and hip movements. The dancers, all women, move in clockwise and anti-clockwise movements. Their graceful, ankle-length skirts and mantles are decorated with fine gold or silver embroidery. The song accompanying the dance consists of simple poetry full of homely details. It is danced to the accompaniment of kettle drums and the *thali,* and sometimes the harmonium. The dance varies between fast and slow rhythms.

The Bhil tribals of Rajasthan perform Ghoomar, which consists of virile, vigorous movements and is similar to *walar* of the Garasia tribe. The songs speak of love, valour, defeat, and the cycle of nature. Though the circular format may be similar, there is little else by way of resemblance between the two. In that sense the Ghoomar represents that unique element of the Indian cultural tradition in which a tribal dance can forego some of its contextual nuances and enter a more sophisticated strata of society.

Another dance that represents the mystic use of music is the Terah-taali performed by women of the Kamad tribe. A religious ritual, it has enchanting elements of dance and music. Two or three women sit on the floor with one foot stretched outward. Thirteen cymbals are tied to their hands and feet. The dancers hold one pair of cymbals each in their hands. Singers with *khadtaal* and *tamboora* take their place behind the dancers. They face the altar of Baba Ram Deoji, a regional deity. The dance begins slowly, the tempo of the singers in tune with those of the dancers. The dancers move their torsos to strike the cymbals tied to their bodies with those they hold in their hands. As the tempo rapidly builds up, it induces a trance-like momentum. In a sense, the dancers are using their bodies as temples for the god they are propitiating with the spirit of their music.

The Chari is a welcome dance performed on the arrival of the marriage party of a bridegroom. Women of the Mali (flower growing) community place brass pitchers on their heads into which they put burning cotton seeds. As they sway and move, their red and yellow dresses and the dancing flame over their heads

Far left: A Bhavai dancer balances seven pots on her head while performing acrobatic feats that involve dancing on the rims of a glass. These performances have now been perfected to captivate the modern visitor to the state.
Left above: Many of the dances in the tribal communities are performed by men, and are characterised by a show of exuberance.
Left: Most instruments in use in Rajasthan have been indigenously developed, and are particular to a community, or sometimes a village. While art-historians are concerned that some of these have already been lost, patronage is hoping to create a revival in those less obscured by the mists of time, such as this nada being played by its exponent, Dhanne Khan.

Left: The school of Kathak developed as a classical style in the court in Jaipur, and has a gharana which is distinctive from the other centre where this dance form was perfected – Lucknow in Uttar Pradesh.
Top: The Gair dancers make a dramatic spectacle as they swirl about in their long skirts, and are popular at various organised festivals.
Above: The music of the folk musician tends to be spontaneous, though these performers are also versed in family histories and can sing them before an audience.
Right: The use of the matka to create a rapid beat is unconventional, but then so are many of the other instruments used throughout the state.

creates an enchanting spectacle.

The Kachi Ghodi is another welcome dance performed by the Bavaria tribe at the time of marriage festivities. It is, in fact, an enactment of the heroic and martial feats of a hero and his horse, usually depicted through an elaborate costume. The dummy horse is made using bamboo, cloth and jute fibre. *Dhol*, *jhalar*, and *bankia* are the musical accompaniments for the vigorous capers of the male dancers as they manipulate their toy horses.

The nomadic Banjara, Nat, Santhia and Kalbeliya tribes are expert dancers. Of late, the Kalbeliya women have taken to professional folk dancing, though the tribe's age-old occupation has been that of snake-charmers. Their dance has earned great appreciation for its sinuous, serpentine grace. The Kalbeliyas dance to the accompaniment of the *pungi* and the *dajli*. Two or three women sing in a high pitched, free-flowing voice, while the others join in the dance.

Many other tribal dances have caught the popular fancy and, with some urban mutations, these dance forms have become favourites with an urban elite. The Ghoomar, Kalbeliya and Bhavai are such dances. The acrobatic element in the Bhavai dance has earned admiration within India and abroad. There are, however, several dance forms not known to most people, and these are deeply embedded in the social life of the Garasia, Bhil and other tribes. The Walar group dance is one such in which both men and women participate, forming concentric circles. The men hold either a stick or a sword in their right hand, and their left arm rests on the shoulder of the person next to them. They move in

Above: A troupe of professional dancers stage the Ghoomar in Jaipur. Usually, the Ghoomar is a dance performed by women only in the privacy of their homes.
Left: Many of the traditions in Rajasthan are as old as the stones on which its history is writ.

unison according to a set configuration of steps. The men sing a poser to women, who then respond wittily, singing lines that are composed on the spot. This gives rise to impromptu creativity, fun and humour, a pattern that is common to all tribal communities. Virtually the same kind of dance is performed by the Maria and Gond tribes of Bastar and Chattisgarh in Madhya Pradesh.

An elaborate dance-drama called Gavri is enacted by members of the Bhil tribe. The dance is an enactment of Shiva and Parvati's life, though only male performers take part in it. Like the Jasnathi Agni dances, this dance too begins with rituals: a trident is pitched, incence lit around it, and lamps placed in its proximity.

At the start of the festive season of Holi, interesting forms of folk theatre are organised at night-long soirees of community entertainment. Such folk theatre is known as Khayal or Rammat. A raised platform is constructed for the staging, and flaming torches are used to light the place, though electric lamps are beginning to be used as a substitute for the romantic, flickering glow of the torches. Famous love stories such as Dhola Maru, Nihalde Sultan or heroic tales of Amar Singh Rathore and Hadi Rani are enacted by male actors who are adept at acting, singing, dancing, improvising and playing female roles. In a musical repartee, the spectators invariably participate by repeating the last line of a couplet or a dialogue. Such audience participation makes a theatrical presentation come alive all the more when prompting and comments help an actor get over lines he may have bungled. A narrator links the storyline and sometimes offers off-the-cuff commentary on the political and social scene. Popular entertainments such as these contribute towards

Above and left: The exuberance and vitality of the music and dance of the region is reflected in the zest with which children respond to it, as participants and as performers, even at a very tender age.
Far left: The Kachi Ghodi dance is a spectacle on account of the elaborate costumes used by the male dancers who re-enact martial and heroic scenes to welcome a bridegroom's procession.
Far left above: The tradition of music is held within families, and is passed from one generation to the next with children trained in the art even when very young.

building a homogenous, harmonious relationship among people belonging to different communities and of a different status.

Puppetry is another social entertainment, provided by the Bhat community. The Bhats are known as the priests of the Charans who, in turn, were known for their poetic talents. The Bhats are basically agricultural labourers, also skilled in the art of puppetry. They originated from the area near Jodhpur and Nagaur in the Marwar region. The approach of the puppeteer creates a sizzle of excitement among the young and old of the village alike. The show is organised by using a cot as a prop to hold the colourful frills and the backdrop. Wooden mannequins are used to represent heroes, kings, queens and other characters from day-to-day life such as a juggler, a rider, a washerwoman or a dancer. In spite of their illiteracy, the puppeteers are imaginative in using waste materials for the making of their puppets. The show starts with the tooting of a whistle by the leader of the group. The wife of the leader plays the *dholak* and sings intermittently. The lead puppeteer also acts as the narrator.

Religious and social festivals are closely knit into the fabric of tribal village and, to a great extent, city life. The simple, unquestioning faith in one's tradition has helped in no small measure to continue the colourful, rich, composite culture of Rajasthan. The cultural traditions which were supported largely by a feudal system are still intact because of their deep roots and also because of the simple lifestyle of the villagers. Though the state's cultural tenets have undergone changes in the face of the onslaught of visual media taking over the place of live entertainment, the basic ground for the cultural traditions of the state still lies in the pastoral lifestyles of its village communities.

Top: Traditionally, performances have never been stage-managed, occurring spontaneously wherever there is a gathering of people, such as at the many fairs that are frequent events in the desert.
Left: Musicians in concert sing of the past and its glories, of gods and their feats, and of their patrons and their good deeds.
Above: A Kalbeliya musician blows into his been, the flute made from a gourd, and which is traditionally associated with snake worship, to set the musical rhythm for a snake dancer.
Right: At a fair, a dancer takes centre-stage, as much to entertain her audience as to enjoy herself, for performers often work themselves into a trance, so avidly do they enter into the spirit of the occasion.

CRAFTS, ARTS AND TEXTILES
A Tradition of Craftsmanship

One of the oldest civilisations of the world, Rajasthan is a storehouse of crafts that are closely interwoven within its social tapestry and living traditions. The illusion of the past flowing into the present is sustained in the beautiful stone work of feudal architecture, and through a way of life rooted in beliefs and rituals, supported by a deep sense of aesthetics and colour. Such traditions are a common thread running through various segments of society. A woman sweeping the streets with a broom, for example, can be seen sporting the same vibrant colours of *bandhani* or tie-dyed fabric as another who is part of the Rajput aristocracy and wears its more sophisticated version in chiffon.

The social and ceremonial sanctity of tie-and-dye fabric, lac bangles, and woodcrafted items essential for marriages and festivals, terracotta lamps and pots, metal toys made specially for a new mother: these and other crafts, though threatened by newer consumer items, still exercise a strong power of cohesiveness in a society that has produced a valiant, reckless race of men and women, as also its most pragmatic and successful business people.

The many courts of the feudal states of Rajasthan played a very definite and crucial role in shaping a craft-oriented economy. This conscious patronage resulted in a range of masterpieces of high quality in everything from architecture to painting, fabric, jewellery, woodwork, ivory-carving and metal work. Friendlier relations with the Mughals of Delhi proved inspirational for the flowering of the crafts. The decline of the Mughals saw many royal craftsmen shifting base to Rajasthan where patronage was more easily forthcoming.

The evolution of craft covers a vast span of time in Rajasthan. Incorporating its primary beginnings in folk culture, the cultural influences from the north, and finally Mughul influences led to the creation of a dazzling court culture. Whether it was the humble terracotta essential at birth, marriage and death ceremonies, or the beautiful *gorbund* camel-ornaments handcrafted by women while they sang, or the vibrant tie-and-dye fabric worn alike by royalty and commoner, the emphasis on faith and rituals and the associated symbolism has remained the single most important factor in keeping its craft traditions alive.

Terracotta, one of the earliest crafts practised by man, continues to occupy a place of exceptional importance whether for utility items or for votive objects. *Matkas* or water pots are primary to life in the desert state — the mouths of the pots are small to prevent water from spilling out when being carried from the well, a natural

Above: Tribal communities decorate their huts with motifs that have mythic origins, and indicate the exuberance with which they wish to adorn every element of their lives.
Left: Windows, alcoves and niches are marked by special attention from the painter who colours vivid patterns using lime on mud-plastered walls.
Far left: A housewife from Jodhpur begins the festive season of Diwali by painting traditional motifs on the walls of her dwelling.

precaution given its rarity, and to prevent the desert sand from entering it easily. Made locally all over the state, *matkas* from Pachpadra, Mokulsar and Samdari in Barmer district are known for the exceptional cooling quality of the clay. These places, along with Pokhran (Jaisalmer district) and Phalodi (Jodhpur district), and Gogunda and Bhutala (Udaipur district), also produce exceptional cooking utensils made of terracotta. Food cooked in terracotta is valued for its very special aroma. *Tavas* or griddles for *roti* are hand made and sold for two to five rupees, each lasting for a couple of months. Inexpensive and nature-friendly, these typify the basic characteristics of most utilitarian crafts in Rajasthan.

The ancient civilisation of Rajasthan has also evolved rustic terracotta as offerings for various local gods. The terracotta images and plaques of Molela, near Udaipur, have gained recognition in big towns and even abroad. This beautiful craft has survived down the years because of the religious sentiments of the tribals and the rural population. People from as far as Jaipur come to Molela to seek the image of their deity. The journey to Molela, to pick up the idol, consecrate it and take it back for an installation ceremony is an elaborate ritual, guided by the subconscious mind of human sociology. These terracotta plaques are in great demand from local buyers in the month of January.

Ahore in Jalore district, produces beautiful terracotta horses as religious offerings. These range from two to almost six feet in height, and April is the time when they are made in large numbers.

Colourful terracotta toys are a fast disappearing commodity, found mostly at the local fairs and *haats*. Bu is one such small village near Mundwa in Nagaur district whose terracotta toys and utensils are popular in the big and small fairs of Marwar. The toys use three techniques — the wheel, the mould and the hand — a tradition that dates back to the Harappan and Kalibangan civilisation. Toy figures of the tiger, bird, deer, horse, camel, rabbit, and idols are popular in fairs around Merta as well as in Balotra (Barmer) and Sathin (Jodhpur).

Silver jewellery, another rural craft, has gone through a distinct change in its status — not in its usage but in its availability. Its popularity is based on its vigour and sturdiness, which has made it a highly profitable export

Top: The tribal communities are known for the bright colours of their mirror-worked embroideries, used for everything from their clothes to the cloths they use to adorn their homes.
Above: Men sit at a loom outside their village hut in Jodhpur district. Weaving is widely practised throughout the state, both by men and by women.
Right: The bright, woollen blankets of Rajasthan have, in recent years, been contemporarised as shawls, most of them intended to feed the requirements of the urban markets.

Top: The potters of Jalore's Harji village are as adept at turning pots as they are at making terracotta toys and images of folk heroes and gods.
Right: Gilded work on marble or wooden bases and gesso work on camel hides for shades go into the making of objects such as these, totally handcrafted by artisans in Rajasthan.
Above: Udaipur's village Molela has become distinguished for its terracotta panels of gods, family deities and folk heroes.

item. As a result, the beautiful hand-made patterns are being replaced with machine-made lookalikes. Old silver pieces are still available, especially in the areas around Jaisalmer, Chittaurgarh, Mt Abu, and Shekhawati.

Rajasthan's rich range of jewellery is a fallout from its elaborate court traditions, and its cities are prestigious centres for the manufacture of gold jewellery. Jaipur and Bikaner are known for *kundan* (gem-setting) and *meenakari* (enamelling). *Kundan* and *meenakari* are often combined so that a piece of jewellery has two equally beautiful surfaces — enamel at the back, and *kundan*-set gems in front. The early seventeenth century saw master-enamellers from Lahore settling in Jaipur, which became the traditional centre for this craft. Jadiyon ka raasta in Jaipur is where most shops are located. Jaipur also excels in the craft of gem-cutting, polishing and setting. Raw stones from all over the world come to Jaipur to be chiselled into their final shape and form. Pratapgarh in Rajasthan is known for its *thewa* work — a special type of quasi-enamelling — consisting of delicate gold leaf work embedded in glass or enamel, and framed with silver or gold to make lockets and boxes. Costume jewellery too is a natural by-product in the jewellery-rich state of Rajasthan with centres at Jaipur, Churu, Nathdwara, Udaipur, and Pratapgarh.

Thread-jewellery, now being fashioned and sold in sophisticated, urban shops, can be traced back to the innate love for decorating in the ordinary items of everyday use. Even the few strands of thread to be worn around the wrist, as part of a simple ritual, are a craft in themselves — bursting forth into myriad colours at the time of special festivals and in the marriage season. *Patwas* or craftspersons making thread attachments for traditional jewellery, can be found outside all the main jewellery shops.

Brass jewellery is now an ebbing craft in Rajasthan with only the Bhil tribals forming its diminishing clientele. It is moulded to order by the Bharava community at weekly village markets called *haats*.

Lac jewellery, largely bangles, are worn on all auspicious occasions. Plain or studded with glass pieces, bright stones and beads, or the inbuilt *lehariya* or zigzag pattern, these are made and worn all over Rajasthan.

Left top: A potter at his wheel. Rajasthan's terracotta continues to be of very high quality because villagers continue to use earthenware for everything from storing water to cooking.
Left: Padma Shree artist Kripal Singh Shekhawat who is responsible for reviving the art of blue pottery in Jaipur, is an artist of renown. Blue pottery is made using crushed quartz and fuller's earth, and has a characteristic blue colour derived from copper sulphate.
Following page: These delicate pavilions of the City Palace in Karauli are indicative of the aesthetic abilities the Rajput warrior kings commanded despite their martial leanings.

Jaipur is a big centre for lac bangles, others being Ajmer, Sawai Madhopur, Bundi, Alwar, Jhunjhunu, Kota, Nagaur and Ganganagar. Inexpensive lac-enamel jewellery is manufactured at Bikaner. It is fascinating watching the coloured resin being heated, stretched, curved and set into bangle shapes over a few pieces of hot charcoal using no more than some simple instruments and deft fingers.

The tradition of colourful, decorated textiles in Rajasthan is a rich one, rooted in social customs and rituals, with a vast range of hand block prints, tie-dyed fabrics and embroideries. *Bandhana* or tying and dyeing is one of the earliest techniques used for decorating fabric with dyes, with designs wrought by a combination of tiny dot-like patterns. The knotted or tied areas resist the colour and retain the colour of the base cloth. The threads are removed according to the dictates of the design and the cloth re-dyed as many times as needed. An additional design of the tie-and-dye technique is called *lehariya*, conveying the effect of waves

Top: Frescos were painted in great detail in the palaces, and the art is still in vogue, though there are fewer takers for it.
Above: Blue pottery being taken out of a kiln after it has been fired at very high temperatures.
Right: These stuffed toys are made by village women all over the state, traditionally as a part of their trousseau, and now perfected in Tilonia, near Ajmer, as colourful embellishments for a home.

or stripes by twisting the entire length of cloth and tying it at intervals. Checks formed by intersecting diagonal stripes is called *mothra*.

Sensitivity to colour expresses itself in symbolism, and colours have come to be associated with seasons and emotions. Red is ceremonial wear, mandatory for weddings, and symbolises love. Yellow is popular at Holi, a spring festival. It symbolises blooms and is customarily worn at childbirth. Green is worn during the much awaited monsoon season which is celebrated as the Teej festival throughout Rajasthan.

The printing centres are naturally located around water resources. The mineral content in the water makes a rich contribution to vegetable dyes, which are once again being revived as a response to market demands. It is now being recognised that the running colour of vegetable dyes leaves the fabric with a new shade and personality each time it is washed and does not, in fact, look faded.

Dyeing and printing is done all over Rajasthan. However, certain areas have come to be renowned for their printing skills — Bagru, Kaladera and Sanganer; Akola near Chittaurgarh, Ahar in Udaipur; Jaisalmer, Barmer and Balotra; Pali, Pipad and Jodhpur. Each region specialises in its own designs, colours and techniques, and caters to the needs of local communities.

Jaipur printing, under the patronage of the rulers, attained a sophistication of its own, producing stylised designs in delicate shades and finely depicted motifs. Sanganer, a village near Jaipur, became the prestigious centre for such prints where work of high quality sustains its export potential today.

Other printing centres used bolder patterns and deep colours on rough fabric to suit the vagaries of a harsh existence. In Bagru, for example, we have a basic combination of red, black and beige. Jodhpur, Pipad and Pali specialise in bold patterns designed and printed in red, black, blue and green. Chittaurgarh is known for floor coverings called *jajams* and printed fabric for women's skirts and wraps. Akola, near Chittaurgarh, is known for its prints in indigo blue, green, alizarine red and yellow.

The desert areas of Barmer are known for the traditional printing of *ajrakh*, using a very special resist printing technique. Consisting of dark shades of blue and red geometrical patterns, *ajrakh* is printed on both sides and used for turbans, shawls and *lungis*.

Embroidery is a household craft in which women and girls of all ages participate. Mirror work incorporated within thread work, originated with the use of mica found in the desert. Exquisite mirror embroidery is widely practised in Jaisalmer, Barmer, Pali and Bikaner districts.

The desert regions of western Rajasthan, where people eke out a living tending livestock, are known for distinctive woollen weaves worn by the local people. The colourful shawls which are also used as blankets, are a native weave in Jaisalmer, Barmer, Bikaner, Jodhpur and

Top: Village women weave baskets with dexterity, their skill with their hands responsible for the adornment of their lives.
Above: Using the most basic tools, assembled in their own villages, khatis or carpenters are able to turn wood into the most amazing shapes.
Opposite page: Masons and carpenters often create similar motifs on stone and wood to embellish the Rajasthani home. In both cases, in spite of basic and crude tools, the final result is a stunning work of art.

parts of Jalore. Deep browns, black and cream coloured natural wool are enlivened by *pattu* embroidery which is practised in Jaisalmer and Nagaur.

A wool producing state, Rajasthan has a huge carpet industry. Carpet weaving found its way to Jaipur through the Mughul courts in the early nineteenth century. This craft has grown and evolved its own style in Jaipur, Ajmer and Bikaner. Fabulous dhurries were once made in the jails of Jodhpur and Jaipur under royal patronage to rehabilitate convicts. Wool and cotton dhurries are made in Jodhpur, Nagaur, Ajmer, Jaipur, Kota, Dausa, Churu, Bharatpur, Alwar, Bundi and Tonk.

Besides the compartively better known traditional weaves, Rajasthan abounds in handloom weaving centres catering to the more practical needs of a modern market. There is a whole array of utility items — table and kitchen linen, turkish towels, jacquard tapestry, shirt material, bedcovers, hospital blankets, fabric from different fibres and weaves in vegetable dyes.

Rajasthani puppets, of great commercial value today, have been used as a medium for traditional story telling. Stemming from Marwar, the puppeteer community spread across the state, living in small clusters in the districts of Jaipur, Jodhpur, Udaipur, Kota, Ajmer and Nagaur. Tilonia, in Ajmer, is experimenting with innovations, using this traditional craft for active, social mobilisation. In Kota too the otherwise commercial, decorative aspect of puppeteering is being used meaningfully.

Jaipur has been known in the past for its cloth animals and dolls. Made of old cloth, dyed afresh and stuffed with waste material, they are gaily coloured with bright shades of paper and tinsel. A commercial venture now, Mishra Rajaji ka Raasta has an interesting assembly unit for handmade dolls. Dolls made from jute fibre have been a thriving craft for the last thirty years in Deena Nath ki Gali in Jaipur. Sirohi and Nagaur district are also known for stuffed toys.

Attractive folk toys in lacquered wood have a vivacity and simplicty that engages a child's mind, and are found at Udaipur, Bassi (Chittaurgarh district), Sawai Madhopur, Karauli, Barmer, Bikaner, Bharatpur, Churu and Kharesh (Nagaur district).

The Kumawat community in Jaipur are traditional ivory carvers. Now, with the use of ivory banned, bones (specially those of camel) are used for making jewellery, paper knives and other decorations. Ivory bangles in Rajasthan are considered family heirlooms, and those that belonged to a woman who died before her husband are coveted as good omens.

Handmade idols for Gangaur, a festival celebrated all over Rajasthan, are linked with mythology and faith. However, two places known for producing beautiful idols of Shiva and Parvati are Bassi (a village near Chittaurgarh) and Bikaner. Although several craftsmen from the village of Barsi have moved to more lucrative businesses at Jodhpur, this place has always occupied a place of

pride in many ritualistic as well as functional woodcrafts. The Gangaur idols traditionally used by the royalty and nobility were made in this village. Kawad, a miniature, mobile temple with several doors painted with colourful folk heroes and deities, and central to a folk narration style, is also traditionally made at Barsi. Although being commercially produced at Jodhpur, Kawads in real life use are disappearing with less than a dozen of the same family engaged in this craft at Barsi. Barsi is also known for its quality furniture and objects with surface carving like animal figures and mirror frames. The wooden Gangaur idols of Bikaner are decorated with special gesso work by the master artists.

Other traditional artefacts which are made and used all over Rajasthan are the *bajot* (a low table), the *toran* (a symbolic piece of carved wood with a peacock fixed atop it is an essential feature of a wedding — the bridegroom has to touch it with his sword for the marriage ceremony to commence), and *choalas* (a peacock-shaped box in bright colours for keeping vermilion). Kolran, near Phalodi, is of singular importance for nurturing the almost-extinct craft of making musical instruments that accompany the folk songs of the Langas and Manganiars. Although there are about four thousand performers from these two communities, since the past six decades there have been no other craftsmen making these instruments, whether in India, Pakistan or Baluchistan.

Inspired by the exquisite stone carving of Jaisalmer, the woodwork of Jaisalmer, Barmer, Chauhtan, Alamsar and Kanoi can be distinguished by its workmanship. Carved furniture, lattice work and window frames, in addition to brass and iron inlay on wooden articles, are popular. Rohida, the local wood, is commonly used, but now *sheesham* and teak are substituted for more sophisticated export items. Wood is a precious commodity in Rajasthan and the products display painstaking and elaborate labour over the raw material. Carved, plated and painted furniture is a major export item in Jodhpur. An antique finish given to this craft to capture the patina of a bygone era is a professional business here. Ivory inlay on wood in geometric and floral patterns has been replaced with mother-of-pearl and bone inlay work on chests, boxes and tables at Jodhpur, Udaipur and Etawah in Kota district.

Top: Rajasthan was once a major centre for the making of swords, shields, daggers and knives, which were then ornamented by jewellers. Today the art survives more to serve the needs of tourists than warriors.
Above: A metal worker crafts a plate, beating the embossed designs into shape. Metalware is also enamelled to catch the glint of liquid colours trapped into shallow hollows to enhance the patterns of a design.

Rajasthan has stone of varied compositions and colour. Makrana in Nagaur district is the major source of its marble, believed to have been used for making the Taj Mahal at Agra. Available in different shades, ordinary household items crafted out of this stone become art pieces.

The comparative scarcity of wood and the natural abundance of stone led to highly artistic stone work in Rajasthan. One has only to look at old monuments and cities to understand the excellence and supremacy of this craft. The ornamental stone work of Rajasthan flowers in its architectural usage in trellised windows, screens, balconies and archways. While creating a play of light and shade to break the harsh desert sunlight, it allows the cool breeze to filter through. The art of *jali* or trellis work converts stone into lace and requires a high degree of capability from the stone cutter.

Rajasthan abounds in stone quarries and sometimes a whole village may be engaged in a single craft of stonework — domestic functional items, small religious idols, or decorative items. Stone carving is a major craft in Jaisalmer, Nagaur, Sirohi, Dungarpur, Banswara, Udaipur, Rajsamand, Bikaner, Jaipur, Alwar, Dausa, Bharatpur and Sawai Madhopur.

Rajasthan is specially known for its marble idols which are made to order from various places across north India. Khazane Walon ka Raasta in Jaipur is renowned for this craft. Kishori, near Alwar, specialises in large images of gods in traditional styles. Often, the eyes for the idols are separately made using enamel work on gold, silver or copper, its centre being at Nathdwara.

Nagaur is a big centre for a range of functional metal crafts. It is the only place in Rajasthan that makes the dyes used for making gold and silver jewellery. These handcrafted dyes are highly evolved and are required to stamp the images of thousands of gods and goddesses of the Hindu faith on pendants of gold, silver, copper and glass. Only about four or five families now do this highly specialised job. Known for making cannons earlier, Nagaur also makes kitchenware of all sizes and shapes. Artisans also make tools for farmers and metal craftsmen shape bells for temples, as well as figures of animals and dancers. The beautiful craftsmanship of Rajasthan's nomadic ironsmiths (many of whom are now

Top: An artiste creates a silver scabbard for a dagger. These were once commonplace, but though the art has endured, it has become merely decorative.
Above: An English tea service, one of several such crafted by silversmiths in London for the princes of royal Rajasthan in designs exclusively created to meet their requirements. In later years, local silversmiths were able to copy the same designs with great alacrity.
Right: Enamelling a piece of silver jewellery – the tradition finds wide usage in decorative objects for homes.

working for the export industry in Jodhpur) and Kaseras (bronze workers) can be seen here.

The Bharava community are traditional metal casters who make tribal ornaments and beautiful animal toys on wheels, traditionally gifted to new mothers. They can be found in the districts of Udaipur, Chittaurgarh, Bhilwara, Dungarpur and Banswara.

Jaipur, Jodhpur and Udaipur are the main centres where damascening, lac-colouring, enamelling, engraving, inlay, punching and casting on metal are known and practised. An addiction to opium, widely prevalent in south and west Rajasthan, has led to the crafting of opium grinders and containers in Barmer and Jaisalmer.

Mojris or *juttees* (leather shoes) are handmade in villages for local use all over Rajasthan. Having a big consumer market locally, *juttees* are fashioned according to the needs of the wearer, and those intended for urban markets are still embroidered with silk thread, applique or bead work. While men are engaged in the rougher jobs of tanning and dyeing and cobbling, the finer work of threads and colours is left to the women. The *mojris* of Bhinmal in Jalore district, and Jaitaran and Nimaj in Pali district are known for their exceptional craftsmanship.

Camel hide is becoming increasingly popular because it is soft and flexible. Innovations for the modern market include embroidered handbags, coin purses, belts and pouches, seats and back rests of chairs. The Social Work and Research Centre at Tilonia in Ajmer district has made great headway in innovating and popularising leather craft. Rajasthan is also known for its membranophonic instruments — the *dholak* and *tabla* are made by the Dabgar community, using camel hide. Almost all big towns have shops selling musical instruments. A beautiful but disappearing craft in Bikaner is gesso work on camel hide in the form of lampshades, flasks and perfume bottles.

It was inevitable that the art of miniature painting should get rooted and evolve its own styles in this land of colours, in the seventeenth and eighteenth centuries. Prominent amongst the schools were Mewar, Kota-Bundi, Bikaner, Ajmer-Jaipur, Marwar, and the smaller but not lesser centres of Kishangarh, Alwar, Ajmer, Tonk and Uniara. Traditionally, these were schools identified with definite stylistic features related to each of these areas. Today, painters across Rajasthan are adept in almost all the styles of miniature painting. The main centres are Jaipur (Samode), Ajmer (Kishangarh, Pisangan), Jodhpur, Udaipur, Nathdwara, Bundi, Kota and Sawai Madhopur.

Above: The enamelled peacock pavilions at Udaipur's City Palace are as much a tribute to the masons and architects of the city, as to the jewellers who were responsible for perfecting the art for the zenanas.
Right: The art of inlay was perfected in the palaces, such as at Jaipur's City Palace, where mirrors, coloured glass and gilding was used to create extraordinarily opulent interiors for apartments.
Far right: Jaipur is a major centre for marble sculpting, and marble images of the gods for consecration in temples all over the country are ordered here, crafted from the marble mined from nearby Makrana.

117

Phad is a colourful folk painting on a large scroll of cloth, depicting the stories of the legendary heroes Pabuji and Deo-Narayanji. In addition, the accompanying Bhopa or priest, narrates the story through mime and song. The painters of the *phad* are from Chittaurgarh, Bhilwara, Raipur and Shahpura. *Pichwais* are painted backdrops with themes of seasons and festivals which are hung behind the Krishna idols in certain Vaishnav temples. Painting is considered a temple service, thus imparting a special quality to original *pichwais*. At Nathdwara, 48 km from Udaipur, the tradition is alive at the temple of Shrinathji.

The traditional centres for handmade paper are Sanganer, Ghoshundi near Chittaurgarh and Sawai Madhopur. Used in miniature paintings, paper was procured from these centres. Today, handmade paper is in demand among an exclusive clientele for diaries, writing sheets, envelopes, and paper bags. Chittaurgarh, Udaipur, Dausa and Ganganagar are other places where handmade paper is made.

The craftsmen who created the splendour of Rajputana, honour its history and traditions, as do the vigorous and vivacious people of Rajasthan who use them and are still steeped in their age-old lifestyles, bound by seasons, festivals and occasions of importance in the journey of life.

Top: The jewellers of Jaipur and Bikaner are known for the fine quality of their kundan jewellery in which uncut diamonds are set into gold hollows to create the pattern of jewellery favoured by its elite.
Above: A major centre for the cutting and polishing of precious and semi-precious stones, Jaipur has also perfected the art of gilded inlay work.
Top left: The glass mosaic panels of Udaipur absorbed the Mughal art of pietra-dura inlay with a definite European influence absorbed by the court artisans who were sent to the Continent by the maharanas to master the art.
Right: There is a strong tradition of zardozi work in which threads of gold and silver are embroidered into fabric, and precious stones set as a part of elaborate fabric intended for ceremonial purposes and trousseaus.

The traditional jewellery often combines kundan and meenakari (or enamel) setting together, to create pieces that are part of any household. These can include the sarpech or turban ornament for men, the elaborate wedding necklace for women, and bracelets for the wrists worn with ivory (now bone, even plastic) and glass bangles.

Opposite page: All dressed up for a wedding, the Rajput woman wears her rakhri on the forehead and an aar around her neck, both part of her own marriage ensemble, and representative of her married status. Rajput women also wear gold on their feet, in the form of toe rings and anklets.

COSTUMES

Textile Traditions

Rajasthan has been associated with the production of colour fabrics in the Maru-Gurjar tradition since ancient times. Both men and women are fond of costumes, making events such as the Pushkar or Beneshwar fairs a spectacular feast of colours. Their sense of colour-aesthetics has led to the use of colours and motifs intended for different occasions. For example, the *lehariya* is a zigma pattern created in the tie-dye process that is specially worn in the monsoons while the *phaganya odhani* or mantle is intended for the spring festival of Holi. There are regional variations too: in western Rajasthan, Garasia women wear *Garasion ki phag*, a veil with a yellow ground and red border, and a large round in the centre. Mina women wear *dhaniya chunari* while Gujar women prefer *rati chunari*, and a Malan wears a *ghaghara* or skirt of *asmani*, *dhani* and *chakari farad* or yardage.

Weaver, dyer, printer, block-maker: all the craftsmen associated with the textile industry were, and are, highly skilled and have been producing fabrics and embellishing it for centuries.

Woollen fabrics have been made in north-western Rajasthan since very old times. The industry arose as a result of poor agricultural lands and a dependence on the rains, making animal husbandry the main stay. The need to shear wool off the skins of their camels, sheep and goats, led to a cottage industry of spinning yarn on indigenous spinning wheels, a job performed mostly by women. The woollen yarn was then given to a weaver for weaving. The woven textile was dyed and embroidered by the women.

The weaving communities consisted of the Kolis, Chamars and Meghwals. The Jat and Bishnoi women were highly proficient in embroidery on woollen fabrics which was done in cross-stitch using multi-coloured threads. Two or three pieces needed to be joined together to make *odhanis*. The woollen *ghaghara* was of a special variety known as *dhabla* which was unstitched and held together by twists of a coloured woollen string. Men too used the same fabric for garments to cover the lower half of their bodies while blankets were to cover their torsos.

Rajasthan seemed to be highly suitable for the use of *khadi*, especially woollen *khadi*. Wool was available in plenty, the old techniques still in existence. Women usually worked on the spinning wheel in their homes, while the weaver communities were adept on the loom. Khadi industries were first established in Godra city (now in Pakistan), and in Bikaner. Two types of *khadi* are now prepared in Rajasthan, a coarse variety, and a fine one. Coarse weaving is used for the making of blankets, *lois* and *pattus* in most regions, while merino wool is used for making finer *pattus*, shawls and *lois*.

Cotton is grown in all parts of Rajasthan with the exception of the desert region in the north-west part of the state. The farmer grew cotton and sold it to traders who, after the process of carding and spinning, gave it further to women for spinning into yarn on a labour charge basis. This yarn was purchased by traders or by the weavers. If the merchant gave the yarn to a weaver, he took back the woven fabric; and if the weaver purchased the yarn, he would sell the ready cloth to the merchant. For example, a *manai* or wholesale mart of the Sanganer and Bagru Chhipas (printers) was a usual feature in Jaipur at its Bari and Chhoti Chaupars where they were sold as finished goods.

Above: Bapji, the head of the erstwhile royal family of Jodhpur, formally dressed, pays obeisance at the family temple at Mehrangarh fort. Even today, ceremonies connected to Dussehra or his own birthday are observed by the nobles who gather at the palace to greet the man who, in another age, would have been a maharaja.
Right: The worship of the images of Shiva and Parvati is a ritual observance at the start of the procession of Gangaur. Such ceremonies carry deep significance for the people of the region, and the colours of their clothes reflects this.

Above: Sanjay Singh Bissau, his wife, and fellow nobles, dressed to attend a wedding in the family where formal clothes are mandatory. Note the brocade tunics the men wear, and the swords they carry as part of the ensemble, and the women's wedding necklaces, called 'aar'. Left: The silver jewellery that tribal women wear could weigh most people down, but since it represents their nomadic way of life and signifies their wealth, the women seem to carry them about their body almost effortlessly.

Bangles clinging to their wrists, silver flashing at forehead and neck, glinting off their ankles, their raiments resplendent in their rich colours, these women are representative of a way of living that is both joyful and vibrant.

There was no place for big industrialists in the entire process, nor were there any servant craftsmen. The craftsmen made their goods and sold them in a *haat* or weekly market. The *jajmani* system of a fixed clientele was also in vogue. Weavers had their fixed clients whom they supplied articles of daily use like *reja*, *reji*, quilt covers, sheets, *khes* etc. With the advent of mechanical looms, things have changed now and many weavers are now employed as wage-earners in textile mills.

In the weaving of fine textiles, the Kota *doria* or *masuriya* is a popular reference. In Kaithoon town, near Kota, a number of families are engaged in making Kota *doria sarees* and cloth lengths in which cotton and silk yarns are used simultaneously. The cotton and silk yarns come from outside Kaithoon. Colourful *butis* or motifs are printed, and *zari* work using gold threads is also done. Though the tradition of cotton textiles is an old one in Kota, the weaving of *masuriya* or fine *doria* work is a recent introduction of this century.

There might have been a lack of political consciousness in the princely states of Rajasthan during the freedom struggle but the use of *khadi* or hand-woven and hand-spun fabric was promoted by all. The rulers of these states loved their subjects and wanted their industries and crafts to be developed. In Jodhpur, Sir Pratap had made it compulsory for all state officers to use *tukari*, an indigenous variety of hand-woven cloth. Maharaja Umed Singh of Jodhpur wore the green dress prepared from the jail-manufactured *khadi* while playing polo. Jaipur had its regular weekly markets of yarns and hand-woven cloth. In fact, the textile industry was considered a handicraft in Rajasthan and never became extinct, only its form changing as per the needs of the times.

The practice of dyeing has been in vogue since ancient times, the oldest method involving only a single colour. Thereafter, the cloth began to be tied and dyed to make ornamental patterns. Literary allusions to tie-dye work are available from the fifteenth century in Rajasthan. The sixteenth century hymns of Meerabai allude to *panchrang*, five colours, spiritually linked to the five elements (earth, water, air, fire and sky). Such *chunaris* or mantles in five colours are still in vogue. The poet Bakhat Ram Shah refers to three kinds of tie-and-dye work in his eighteenth century treatise, *Buddhi Vilas* in which he writes of dyers dyeing colourful *lehariyas*, *chunaris*, and the even more proficiently executed *pomchas*.

All three forms of tie-dye are still available today. In the *chunari*, creepers, flowers, leaves, birds, animals and other motifs are made using a pattern of dots. *Chunaris* are dyed all over Rajasthan, but those of Jodhpur are unmatched in their workmanship. A popular verse from a song has a woman asking her husband: 'I have a craving, dear, I bow at your feet. O noble one, please get me a *chunari* from Jodhpur.'

Dhanak is a variety of *chunari* in which small dots appear at even intervals. *Pagaris* (turbans) with *dhanak* patterns find mention in medieval writings.

In *lehariya* style tie-dye, a pattern of waves is created with stripes by tying the cloth from both sides. In its *mothra* version, intersecting stripes are formed, and in the case of an angular *mothra*, a pattern called the *mothra gandadar* is formed. The *lehariya* is highly popular in Rajasthan, both among men and women. Especially during the rains, women demand new *lehariya odhanis* from their husbands. Poet Malik

Whether a nobleman dressed up for a wedding in a brocade tunic, or a peasant in his everyday wear, the turban forms an important part of their head dress, and a little jewellery never goes askance. Top left clockwise: A nobleman from Bikaner wears the traditional chunari; the kesariya turban of a Rajput peasant from Jaisalmer; the state turban of Mewar; the saptrangi worn by the Rathores of Marwar; the typical safa of Udaipur; the distinctive turban of the community of Bhats. Facing page: While the colours of the turban and the manner in which it is wound around the head is indicative of the social status as well as region from which these men belong, their clothes, jewellery and even the way they wear their moustaches and beards can help to pinpoint the community from which they hail.

Top: The perky turban with the plume and the tail as characterised by this red one worn by a palace attendant has become the more popular style in the towns of Rajasthan. It was first introduced in the durbar in Jodhpur.
Top middle: This characteristic turban with its bands of orange and red, dyed in precise colours, is typical of those worn in Mandawa, a feudal settlement in Rajasthan's Shekhawati region. Families would sometimes help to evolve colours that were intended for their particular use.

Muhammad Jayasi, the author of Padmavat, refers to these as *samudra-lehar* (sea-waves). One particular style came to be known as the *Pratapshahi lehariya* after a king's name; turbans dyed a dark pink in the *mothra* pattern came to be known as *Rajashahi*.

In the *pomcha* variety of dyeing *odhanis*, the borders on all four sides are in dark red or green, and the ground a light pink or yellow. Four small flowers are made on each of the four corners, and a bigger one in the centre, in the tie-dye style. *Pila* among the *pomchas* has red along the borders, with a yellow ground. Considered auspicious, the *pila pomcha* in particular is usually presented to a new mother by her parents.

The process of dyeing begins with the outlining of the motif with *geru*, Indian red, on cloth pressed into many folds and then given for tying. Guided by the *geru* outline, the cloth is picked up by fingernails and tied into small knots using cotton thread. Once finished, the fabric is handed over to the *rangrez* (dyer) for dyeing. The second colour of the motif is again tie-dyed in the same manner, and repeated for each colour intended in the pattern. The order followed for dyeing involves moving from lighter hues to the darker shades.

Conventionally, only red, green and maroon colours were used, but with the easier availability of synthetic dyes, newer shades that have been included are violet, blue, chocolate, and several lighter colours resulting in brighter *bandhej* (tie-and-dye). According to a newer technique, the spots where the designs are to appear are first dyed with wet colour bags, and then the tying proceeds as per the motif. After the tying, the cloth is bleached for removing any spots about it, and the pattern is secured inside the knots. The ground is then dyed in the desired colour. It is on the basis of the knotting that the patterns of the *chunari* and the stripes of the *lehariya* are made.

With the founding of Jaipur, the *neelgars* (dyers) migrated here from Amber. Since the history of the last three centuries of Jaipur can be authenticated from the diaries preserved in the State Archives, Bikaner, historical material with regard to the royal dyeing workshops is available. It records the purchase of vegetable dyes obtained from vegetation and mineral sources, and the range of popular colours these would help to recreate. Jaipur continues to be a prominent centre for the dyeing of cottons, muslins, coarse *reji*, pure and artificial silk, georgette, and chiffon. The *neelgars* of Neelgaron ka Nalla, Ramganj Bazaar and Tripolia Bazaar are involved with a wide range of tie-and-dye works.

The Shekhawati area is known for its *bandhej* dyeing. Sikri *bandhej* has come to imply very fine tie-and-dye in common parlance. It is a tradition that dates back to five centuries when two brothers, Phool Bhati and Bagh Bhati, began this work here. Known for its *pila, pomcha, chunari,* and *sarees*, it uses complex patterns of creepers, vines, paisleys, and bird and animal figures, all of them finely detailed.

Gujarat and Rajasthan, which form the old Maru-Gurjar region, are quite famous for their celebrated chintz. Literary evidence points to its antiquity and popularity. Locally, printing with blocks is referred to as *thappa chhapai*. Block printing is believed to have started in India during the early years of the Christian era. The Sanskrit classics of Kalidas and Bana mention an *odhani* with a geese pattern, and the Sanskrit and Prakrit lexicons contain the words *chhimpava* meaning *chhipa*, the printer, and *uchchho*, meaning the printing industry.

Above: These silver ornaments are usually worn by a bride on and soon after her marriage. They would be too inconvenient to wear every day.
Right: A woman's ensemble consists not only of her elaborate dress of a long skirt and mantle teamed with a blouse worked with embroidered motifs, but also of the jewellery that includes bangles, necklaces, forehead and hair ornaments, and embellishments worn around the waist, ankles and toes.

The presence of these words in old dictionaries indicates the presence of people associated with this craft.

Printed cotton fabrics discovered at the excavation site of Al-Fostat in Egypt indicate their popularity in African countries. Goods exported from India in the medieval ages included, mainly, printed cotton. During the seventeenth century there was a great demand for Indian chintzes in European countries. In 1683, a dealer in Europe wrote, 'You cannot imagine what a great number of the chintzes would sell here, they being the wear of gentlewomen in Holland.' The trade of printed cotton increased from ordinary towelling and simple linen to house furnishings of high fashion. The British East India Company made good profits from the trade, as old correspondence from its officials proves. Such correspondence also refers to the broadcloth printing industry of Ajmer.

A *safa*, turban, preserved in the Sawai Man Singh II Museum, City Palace, Jaipur is a fine example of the printing craft of Sanganer. Dense fillings of *neem* leaves on a cream background, with shrubs and *butas* on the *pallu*, border, are indicative of the quality of the work in that period. The date of its printing (1799 AD) stamped in a corner indicates its being made during the reign of Maharaj Pratap Singh.

In Rajasthan the term *rangai* (dyeing) was used not only for dyeing or tie-and-dye, but colloquially also came to refer to the printing of cloth. Documents from the seventeenth and eighteenth centuries mention *buta-rangai*, meaning textile printing. A resist paste was applied on the block and pressed on the fabric before dyeing. The cloth was then dyed as per the colour scheme of the *bhant* (pattern). Printing and dyeing was done repeatedly. This technique continues to be in vogue and is called dabu-resist printing.

The printing tradition is common to all parts of Rajasthan, but Sanganer has become known for its direct printing, Bagru for resist printing, Bhilwara for indigo dyeing and printing, and Barmer for the printing of *ajrakh* and *malir*. Good *ajrakh* printing was once also undertaken in Jaisalmer, but in the last decades the families of dyers have moved out of this settlement.

Prominent centres of printing in Rajasthan included Ajmer, Jodhpur, Bhilwara, Kota, Udaipur, Barmer, and Jaisalmer. The catalogues of the Indian Handicrafts Exhibitions held during the nineteenth century provide a lot of information about the textiles printed in Rajasthan. *Chadars*, bedsheets and curtains were printed on a large scale in Ajmer for which English broadcloth was specially procured, in addition to the printing on the cloth produced locally. Sir George Watt in his book 'Indian Art at Delhi' writes that *jal* — the overall pattern of flowers and leaves over white, cream or *pyaji* ground was printed on Ajmer textiles. Motifs were outlined in black and shades of red used for the filling in of colours. Creepers on all the four sides had flowers shaped like palm-leaves in two shades of red. Both ends were left blank. On the *pallus* of *sarees* and *dupattas*, a pattern of arches was conventional.

In Jodhpur, printing on coarse *reja* cloth, similar to that in Jaipur, was used for the *ghaghara* — the long skirt worn by women. The ground was dyed dark red, moss green or blue, and the filling was done in red, yellow, or simply left white. Patterns were mostly geometrical, and used rows of motifs. High quality printing of *dupattas*, *pagris* and waistbands was undertaken in Udaipur. Floral *butas* and *kalangas* in maroon

Left: A woman peeps shyly from under her mantle. For many of them, life is usually observed from behind the purdah of the veil. The nath or nose-ring is a decorative feature of their jewellery, and the Bishnois wear the most elaborate girdles in their noses.
Top: A Jat woman wears graded bangles all the way from her wrist to her upper arm, as a mark of her marital status. Once these would have been of ivory. Amazingly, the women are able to go about their chores despite the burden of such ornaments.
Above: A noble woman wears her traditional dress, substituting the cotton fabrics most others wear with silks, brocades and chiffons on which delicate embroidery has been done, and uses only gold jewellery.

and a light shade of red was used for printing on a white or cream ground. Sometimes flowers and leaves were also printed in green, as has been shown by Watson in his book 'The Textile Manufacture and Costumes of India' (London, 1866) which depicts printing in green, blue and dark red on white cotton ground, with *butas* on its *anchal* (body). Resist printing was undertaken in Kota, the patterns printed with resist paste on white cloth and the cloth dyed in blue or red. On drying, the pattern showed in white, and the ground was blue or red.

A study of textual exhibits in various museums in the country helps provide a better understanding of the tradition of printed textiles in Rajasthan. A very good collection of Sanganer prints is available in the Calico Museum, Ahmedabad, S.M.S. Museum, Jaipur, Bharat Kala Bhavan, Banaras Hindu University, Varanasi, and the Indian Museum, Calcutta. The ground in them is light blue, moss-green, pink ochre or golden yellow, and the composition of flowers and plants is attractive. The Sanganer printers depicted the buds, blooms, and some-

Left: Tie-and-dye is done using a process in which threads tie off areas that are not to be dyed, creating patterns with such points that, when opened, can form an intricate jaal.
Above: Dyers drying the typical peeliya-odhani or mantle with its dramatic red and yellow motifs which is worn with pride by women since it signifies that they have been able to bear an heir to the family's lineage. These mantles will probably be teamed with a dress and embroidered before they are sold in the market.

Below: A nobleman from Govindgarh, near Pushkar, dresses in formal wear, complete with rows of pearls, emeralds and rubies, the preferred wear for those of such lineage.
Below left: These Rajputs from the village are dressed up for a formal occasion, though their elaborate ear rings and chains are a part of their daily wear.

times the entire plant of flowers like rose, lotus, lily, narcissus, marigold, magnolia, oleander, *vaijayanti*, and *jatadhari*. During the fourth quarter of the nineteenth century, when the museum was being built in the Ram Niwas Gardens, Jaipur, Col. T.H. Hendley collected prints of the motifs then in vogue, and this has now become a source of invaluable reference. Textiles printed in Jodhpur, Baran and other places are also available in these museums, but they do not date back earlier than the nineteenth century.

Textile printing in Rajasthan was a flourishing trade and the *chhipas*, *neelgars* and *rangrees* all worked together in preparing textiles. The contribution of the block makers and lathe operators too was substantial. The Census report of Jodhpur state, 1891, gives us the following details about the *chhipas*: that they dye and print textiles; that there were 3,907 *chhipas* in Marwar including 2,025 males and 1,882 females; that besides dyeing, some of them were engaged in tailoring, and in carving stones; and that those living in villages were

135

engaged in farming as labourers.

The procedure for printing on textiles is as follows: the unwashed and unused cloth is cut as per the required size. The ground is prepared by removing the starch from the cloth with cowdung mixed in water. The cloth is soaked in this solution for twenty-four hours, and then washed clean with water. The cloth is then spread for drying in the sun, preferably on a riverside. As it starts to dry, more water is sprinkled on it, so that the exposure to the sun gives it more whiteness. Following this, the cloth is yellowed in a solution of myrobalan powder, sesame oil and water. The outlines are first printed using blocks, and then they are re-used for printing the second colour. A good beating and wash removes the gum from its colours. For colour fastening, the dyeing uses the alizerin process, in which *dhak* flowers are used. Then follows the finishing of the cloth. Traditionally starching was done before calendering, but now the cloth is first calendered and then starched.

The nomadic tribes of Rajasthan follow their own technique for creating textiles. The Kalbeliyas, for example, make a *gudari* of worn out fabrics. Sewn in a simple running stitch, the upper part of the *gudari* usually has a new cotton fabric dyed in *geru* (Indian red, the colour of earth). This part is decorated with coloured thread, also in running stitch. *Gudaris* are used for everything from dresses to bedcovers, bags, and coverings for their snake baskets. In more recent times, the *gudari* has become popular among tourists for both clothing as well as household linen.

Embroidery is a popular way of embellishing textiles. Not much is known about ancient Rajasthan, but examples of embroidery from the medieval ages are available in museums. Records in the State Archives reveal that the garments used in royal households had *mukaish* work. Embroidery using *badla*-flattened metal wire is called *mukaish*. Tiny dots are impressed on the fabric in this process, and a cluster of these can be used to make patterns of leaves and flowers. *Mukaish* was done on *odhanis* for women, and *pagaris*, *jamas* and waistbands for men. The Suratkhana records of the erstwhile Jaipur state make mention of *mukaish* work while describing the portraits of the maharajas.

Mention has also been made in these records of cross-stitch and *kasooti* embroidery on *odhanis* worn by Bishnoi women. This work continued up to the beginning of this century. A form of embroidery similar to the satin-stitch, is known as *soof* and *kharak*. In *soof* embroidery the threads are counted for filling. The embroidery uses multicoloured threads on a red or maroon cloth. In the five decades since independence, the tradition has been enriched with the settlers from Sind who have migrated here.

The *sujani* work of eastern Rajasthan is of a very fine quality. An old cloth is folded three or four times and stitched together, and new cloth is then attached over it for doing chain and running stitch embroidery of creepers and flowers, and sometimes of *sakhi* or peacock design. The *sujani* style of embroidery is used for winter wear, also especially for making *sadaris* (jackets). Embroidery is also done in south Rajasthan where chain-stitch on leather has gained a name for itself. In earlier times, this work was done on scabbards, shield-cushions, and on covers for gun-powder bags.

Narrow borders woven with *badla* (flattened gold, silver or metal wire), known as *gota*, was a popular form of embellishing textiles during the medieval ages.

Top: A bride is expected to take part in rituals and ceremonies for a considerable part of the first year of her marriage, aimed at making her feel comfortable in her new home.
Middle: Garasiya women dress in bright, painted chintz cloths that are usually brought to them by Chimpas or printers. These bright fabrics are especially printed for the women of this community.
Above: Bishnoi women dress flamboyantly, both their clothes and their jewellery characteristic to them, though their men are almost austere in their preference for white, even in the turbans they wear.
Right: A woman at her loom is making woollen and cotton blankets and shawls. These colourful weaves, once the preserve of only village and tribal communities, are now extremely popular in the cities, though the elite in Rajasthan may still not be partial to them.

Gota is woven on looms in Rajasthan and consists of a warp of cotton yarn and a weft of *badla*. Attractive designs consisting of flowers, leaves and decorative motifs could also be made on *gota* by pressing it under blocks. Each pattern and motif had its own distinguishing name. Small pieces of *gota* were cut and patched over the textile with the help of thread and needle to create designs in applique. In Jaipuri dialect, this is known as *chatapati* work. Gota has maintained its popularity even today among the women, the only difference being that the hand-operated loom on which it was formerly made is now power-driven.

Traditionally, men in Rajasthan wore the *pagari* or *safa* on their heads, an *angarakhi* on the upper torso of their body, and *dhoti* or *pajama* below it. The *pagari* was, and still is, an important element of a man's attire. *Pagaris* are of various types — simply dyed in one colour or in the tie-dye styles of *lehariya, mothra* and *chunari* patterns. The dyers of Jaipur created the Rajashahi *pagari* using *lehariya* stripes in a rich pink for the use of the royal princes. While the tying of turbans was essential, the styles used for its tying and fastening were different among castes. There were other differences too, as for

Though they both wear turbans, necklaces, and would stand out anywhere for their confidence, these two men have little else in common. The boy from Jalore wears more jewellery and is resplendent in red, while the Bishnoi elder is characterised by the stark austerity of his white clothes. The Bishnoi male always dresses in white, the female more than making up with the brilliance of her colours and the quantity of jewellery she sports.

Above: An attendant at Junagarh fort in Bikaner winds the lehariya turban around his head as a part of the ritual of getting dressed. While most people in Rajasthan are familiar with the tying of a turban, there are also people who have specialised in the art and are in great demand at auspicious occasions, when their services are requested in homes all over the state.
Left: A turban can be as little as nine metres in length, though in many cases it is much longer, its drape protecting its wearer from the harsh heat of the desert.

example the Udaipuri *pag* which was flat, the Jaipuri *pagari* which was angular, and the Marwari *safa* which has bands that are slightly curved.

Tying a *pagari* is a rare skill. As the proverb goes, 'A *raga* in music, taste in food, and knots in a *pagari* are rare accomplishments.' *Pagari* shops used to keep specially trained staff to tie the *pagari* on a customer's head, a trend still in practice. Such professionals remain extremely busy during the marriage season. The palaces too offered employment to such *bandheras*, and the last *khasa bandhera* or person allowed the privilege of tying the turban on the maharaja's head, was given a *jagir* (grant of land) by the royal family.

Angarakhi, a derivation from the Sanskrit *angrakshak* or body guard, was in use throughout Rajasthan. People wore *angarakhis* made of locally manufactured cloth for daily wear, and reserved printed *angarakhis* for ceremonial wear. The length of the *angarakhis* varied from the waist to below the knees. The front cut of an

Above: While the Rajput women wear full skirts, tribals tend to wear shorter ones, but with more gathers, leaving their ankles free. This is useful when they have to go about their chores, and allows a glimpse of the anklets they wear with such insouciance.
Left: The women wear their jewellery with pride, and almost all of it together, since it reflects the family's wealth.

angarakhi was round or long, and sometimes it was kept uncut and not open. The cut was only suggested by a decorative border. Such *angarakhis* were open on the front and used *ghundis* (knobs made of cloth) and *tukamas* (loops) to fasten it. In winter, *angarakhis* padded with cotton wool were worn by the affluent.

Angarakhis with embroidery around the neck, shoulders and back were known as *farrukhshahi*. The embroidery used *kalabattu* or silk threads and sequins. In severe winters, people wore *atmasukh* (comfort for the soul) over their *angarakhi*: a long dress with cottonwool padding and short, narrow sleeves.

A cummerbund or *patka* was a part of medieval upper class costume, peasants using a piece of cotton fabric one-and-a-half metres long and about a metre wide, which they placed around their shoulders. Brahmins used *dupattas* which were also put on the shoulder. In medieval times the *patka* served two purposes: it girded up the loins and gave agility to the body, and it was

used for tucking weapons into the waistband. It started becoming more gaudy and less useful from the late eighteenth century on, and degenerated in the nineteenth century. By the twentieth century the manufacture of *patkas* had ceased.

A woman's outfit consists of a *ghaghara*, *kurti-kanchali*, and *odhani*. The *ghaghara* is an ankle-length skirt. With the help of gussets or pleats, it is kept narrow at the waist and allowed to flare downwards. It is kept just short enough to show the ornaments adorning the woman's feet. The *ghaghara* did not always have such a wide skirt, but by the nineteenth century the number of pleats used in its making came to signify the measure of one's prosperity. It was not folded at the lower hem; instead, a width of coloured fabric was sewn underneath. A cotton *ghaghara* was dyed or printed to enhance its beauty and then decorated with *gota* borders. Like the *pagari*, fabric for a *ghaghara* was also dyed in *lehariya*, *mothra* and *chunari* styles.

The *ghaghara* continues to be in use. Peasant women wear printed cotton *ghagharas* while Mali and other agriculturists wear *ghagharas* embroidered with artificial silver *zari*. Among village folk, cotton *ghagharas* woven in black and red horizontal stripes are also popular. A *ghaghara* is heavily decorated if meant to be worn on festive occasions. Sometimes a decorated border prepared separately is stitched on to the lower edge of the *ghaghara*, while small floral motifs are stitched on the body. Broad *lappa* — a lace made of gold or silver flattened wire as weft, and cotton warp — is also used as a border. In this case the ground of the *ghaghara* is decorated with *gota* or *gokharu*, sometimes a narrow ribbon of *gota* is stitched on the joints of the gussets. *Kurti*, a long, sleeveless blouse comes up to the waist while the *kanchali* (a short blouse with sleeves) together make the upper garment with the *ghaghara*. In Rajasthan, there is a custom that unmarried girls wear a blouse of one piece, while the two-piece ensemble is worn only after marriage.

The *odhani* is worn to cover the head and shoulders. About 2.5 to 3 metres in length, and 1.5 to 2 metres in width, it is tucked into the *ghaghara* at one end, while it hangs gracefully from above the body at its other end. The *odhani* for daily wear is usually of cotton *mulmul*, dyed or printed and decorated with an edging of *gota* or *kinari*. For festive occasions, *odhanis* are dyed in various colours and use costly borders and *gota*.

In Rajasthan, leather shoes have been worn since very old times. Sand heats up fast during summer, therefore both men and women use *mojaris* (leather shoes). Made with camel or goat or sheep skin, those using camel leather are particularly soft. Sometimes, intricate embroidery is done on velvet or brocade, and then the piece is pasted on the outer part of the shoes.

While lifestyles are changing even in Rajasthan, the people continue to abide by the heritage of its costumes and textiles.

Top and above: Almost every part of the woman's body has its own, special jewellery that is slipped on, pinched in, screwed, or tied to confine itself to that area.
Right: The veil or purdah is usually a sign of modesty, and though its practice in everyday life, especially in cities, is being reduced, it is still required at traditional gatherings and at marriages. Married women, however, continue to keep their head covered with their veil in the presence of their elders.

NOMADS AND TRIBALS
The Face of a People

*N*omadism has been defined as a way of life involving 'repeated shifting of habitat in search of subsistence'. Nomads can either be 'true', 'semi-nomad' or 'semi-sedentary' depending, respectively, on whether their peregrinations are permanent or round the year, combined with some agriculture at their base-camps, or seasonal. Rajasthan has had a substantial incidence of seasonal migrations either as an adopted way of life or a scarcity-induced aberration.

THE NOMADS

Gadoliya Lohars: The Gadoliya Lohars (bullock-cart blacksmiths) of Rajasthan form a major and substantial group of nomads. Also referred to as Gaduliyas, they are found in Rajasthan, Gujarat, Madhya Pradesh, Punjab, western Maharashtra and western Uttar Pradesh. In Rajasthan, an estimate made in 1955 gave their population at about 17,000. The 1931 Census classified them as a functional caste and described them as a sub-division of Hindu *lohars* or blacksmiths. It also mentioned the tradition according to which they were expelled by the Brahmins of Chittaur. The more romantic version now generally current is that the Gadoliya Lohars left Chittaur at the time of its sack in 1568 and took five vows namely, that they would not enter the fort, build houses and live in them, sleep on cots, light lamps, or keep ropes for drawing water from wells, until such time as the fort again gained freedom. It was in accordance with this version that in 1955 a function was arranged signalling the fulfilment of their vow. It is another matter that they continue to lead a nomadic life or build makeshift 'houses' at what used to be their roadside camping sites while being averse to living in houses specially built for their rehabilitation.

A wandering, artisan class, they stay at a place while there is a demand for their services, and then move on in search of newer clients. The fact of their becoming 'roadside' *lohars* in many instances signifies the availability at such sites of custom round the year. For itinerant Gadoliyas, the working season begins after the rains, in September, while April-June forms the off-season.

Banjaras: In his classic work 'Saarth-wah' (Caravan Leader), Dr. Motichandra furnishes an account of ancient trade arteries on land as well as water, and of the caravans and merchant vessels which traversed them. One such land route started from Dwarka, crossed the Thar desert and went on to Kamboj (Central Asia) and beyond; the Mathura-Ujjain-Surat-Paithan route skirted the left bank of the Chambal; the Delhi-Ahmedabad route went via Ajmer; the Mathura-Karachi route went via Bayana and traversed the Thar. The Banjaras of Rajasthan are the descendents or successors of the ancient frequenters of these and other trade-routes.

The Banjaras have included Hindus as well as Muslims and various groups of itinerant traders. The 1891 Census report for Marwar includes persons of Bhat, Rajput, Charan and Jat extraction as forming this occupational community. Col. James Tod mentions a *baalad* or *taanda* (oxen laden with goods) with 40,000 bullocks. There are umpteen references to 'Lakhi' Banjaras — traders with 1,00,000 bullocks — and their pomp and munificence. Jehangir in his memoirs mentions inducing the Banjaras to accompany the imperial army to Kandhar. The laden bullock of a *baalad* has been cited as a symbol of opulent grandeur in the well-known 'Vinayak'

Above: A group of Rebari men, distinguishable in their white clothes and red turbans, have come to participate in a religious fair.
Left: A Rebari elder sips at a cup of tea; the staff and the embroidery on his clothes are characteristic features of the community.
Right: A Rebari couple in their home. The Rebaris continue to live a nomadic life, spending the greater part of their time with their flocks of camel and sheep in search of fresh pastures and grazing grounds.

or 'Bindayak' song of Rajasthan. Writing in 1825, Bishop R. Heber wrote this about a Banjara encampment near Nasirabad: 'We passed a large encampment of Brinjarees, or carriers of grain, a singular wandering race, who pass their whole time in transporting this article from one part of the country to another, seldom on their own account, but as agents for more wealthy dealers. They move about in large bodies with their wives, children, dogs and loaded bullocks. The men are all armed as a protection against petty thieves. From the sovereigns and armies of Hindostan they have no apprehensions. Even contending armies allow them to pass...' Further on, he chanced on another group carrying salt to Malwa and observed that the men were fine-looking and powerful, though not tall, while the females 'were the largest and most masculine whom I have yet seen in India'.

Times have, however, changed: trains and trucks have taken over the Banjaras' work. A souvenir published by

the Tribal Research Institute, Udaipur, in 1966 on the occasion of the Banjara conference in village Bamania of Tehsil Railmagra, stated that it was difficult to find any itinerant family among the Bamaniya Banjaras of eastern Rajasthan, though the Maru Banjaras of western Rajasthan were still partly itinerant. The settling down was done either in new Banjara villages or in the form of separate Banjara *khedas* (encampments) in villages with a mixed population.

Nayaks: The Nayaks or Thoris formed another vagrant community of Rajasthan. In Punjab, they were known as Aheris, Nayak being an honorific term while Thori was a somewhat contemptuous appelation. The Nayaks were devout followers of Pabuji, the famous Rajput saint-warrior, and many among them have been proficient singers of Pabuji's legends and other songs. The 1891 Census report for Marwar designated them as professional thieves.

Some kindred vagrants: Occupation has been one of the major factors in the crystallisation and furthering of castes in India. And curiously, though not altogether illogically, there have been castes devoted to 'even such out-of-the-way' occupations as thieving, prostitution, acrobatics, sleight of hand, and exhibiting animals. Again, some of these fringe groups exhibited a talent for music and dance and, understandably, often had a vagrant lifestyle. Writing in 1882, H.B.Rowney included these 'wild tribes' under the general head of gypsies: 'In some parts of India this people are called Bedyas, in others Nats, in others again Kanjars and Bajigars, leading the same vagabond life everywhere. Some were Hindu, some Muslim, but the one common bond' was thieving. Writing around the same time, Shyamaldas, author of 'Veer Vinod', a history of Mewar, included the Banjara, Kalbeliya, Sansi, Satiya, Kanjar, Bagaria (Gadoliya) Lohar among such vagrants.

According to Russell (Tribes and Castes of the Central Provinces of India), 'The term Nat...appears to be applied indefinitely to a number of groups of vagrant acrobats and showmen.... It is almost certain that a considerable section...of the Nats really belong to the Kanjar or Beria gypsy castes, who themselves may be sprung from the Doms.'

Kanjars: *Khane ko naheen milta tha kuchh/Chhipne ko jagah naheen milti thee/Kisi jagah par Kanjar deekhe/Golee dhadadhad chalti thee...*' (There was nothing to eat and no place to hide. Whenever a Kanjar was sighted, the bullets flew...') Thus goes the song which the Kanjar women of Ramnagar in Bundi sing. Ramnagar's was one of the settlements the government ordered for monitoring and controlling of the vagrant bands of Kanjars and Sansis. Village monographs about Ramnagar and Bagor, 1961 Census, contain excellent records on these communities and their uneasy, forced sedentarisation.

Sansis and Nats: The Kanjars are believed to be part of a race that included Sansis, Haburas, Bediyas and Bhatus. The Sansis and the Kanjars were originally identical or very closely connected, while the Nats or acrobats were a slightly more distant kindred of the two. The Sansis were the bards of the Bhangis, the Nats of the Meghwals, and the group among them known as Raj Nat of the Gujars. According to one view, the gypsies of Europe were sprung from the Doms, Kanjars and Nats.

Kalbeliyas: Closely allied to the Nats are the Kalbeliyas or snakecharmers who form another small group, traditionaly itinerant but now taking to a settled way of life. They occur under different names in various parts

The tribal way of life is often nomadic, and it is not unusual to see groups of people setting off with all their worldly possessions. These can be migrations that are cyclical, and involve larger groups of communities, or simply driven by the need to find fresh pastures, or temporary employment. These wandering communities have often provided important services to people who live in permanent settlements.

of the country. Crooke in his study of the tribes and castes of the then north-western India grouped them under Nats and Kanjars. Russell in a similar study pertaining to the then Central Provinces also described the Garudis, Madaris and Nag-Nathis as a part of the occupational group of Nats who in turn belong to the gypsy Kanjars and who themselves may be sprung from the Doms.

On the plane of theology and religion, the Kalbeliyas will appear to be a fringe group of the great order of Jogis or Naths, and belonged, perhaps, to the Kapalik order of Jullundhernath and Krishnapad which was subsequently assimilated, albeit partly, in the order of the Naths as reorganised by the great Gorakhnath. It is said that Kanipa saved Gopichand from the ire of Jullundhernath by playing a prank which earned Kanipa's followers (the Kalbeliyas) the curse of earning a living through sleight of hand and stratagem. There are many outward similarities between the Jogis and the Kalbeliyas, such as the Nath surname, the practice of sporting *mundras* (ear-rings), *singi* (from *shringi*, a whistle made from horn and representing the male principle), *pavitri* (a ring-like contraption, representing the female principle), and *seli* (multiple black strings worn round the neck).

In addition to displaying snakes and dispensing cures and talismans, the Kalbeliyas also indulge in wayside jugglery and feats such as the swallowing of swords, materialising balls and coins. In addition, many of the males are adept singers and players of the *pungi* (gourd-pipe), and the women have a talent for both song and dance.

Van Vagaris: The small vagrant tribe of Van Vagaris lives by hunting and foraging and occurs mostly in Nagaur district. In an article in 'the India magazine', V.N. Mishra informs us that 'Their annual movement cycle takes place in a radius of about fifty kilometres. They periodically come back to a place which is their semi-permanent base.' Their habits and their isolation put them 'beyond the pale of the caste structure of Hindu society' and this, coupled with their aversion to jobs involving regular hours of work, the shrinking of their habitat and the growing paucity of game, foretell a time of increasing difficulty for this, otherwise, honest, law-abiding and peaceful community.

Rebaris: While the Banjaras and the Gadoliya Lohars, nomads by definition, have either already settled down or are in the process of settling down, the Rebaris or Raikas still spend the greater part of the year roaming with their flocks of camel and sheep in search of grazing pastures. The Rebaris are found mostly in the Pali, Sirohi, Jalore and Jodhpur districts. M.L. Parihar informs us that while they spend the rainy season in their villages, the remaining eight or nine months are spent away from home, Malwa in Madhya Pradesh being a favourite destination. However, in recent years the annual exodus from Marwar, made more intense when the rains fail, has given rise to tension, even confrontation, between the local farmers and the forest department, on the one hand, and the migrant flocks and their owners on the other.

The expression 'colourful' is perhaps the most flogged in tourist literature, but its use in the context of the Rebaris is unquestionable. There are few sights more pleasing to the eyes than that of the hardy and cheerful Rebaris marching manfully on with their flocks.

Top and above: The tribal and nomadic communities have provided many of the essentials to a desert life, and have come to represent the smiling face of Rajasthan in spite of the many adversities that are part of their lives.
Right: A Bhil tribal in traditional gear. The Bhils are among the original inhabitants, particularly in the Mewar and Dungarpur areas, and have been great warriors adept in guerilla tactics in the past. Today, they are more known for their colourful celebrations.

151

THE TRIBALS

Sahariyas: 'Brahma, the creator was busy casting the Universe. He made out a place to seat all persons. In the centre of the place he placed one Sahariya who was a simpleton. As others came, they also began to sit and gradually pushed the Sahariya to the further end of the square. By the time all had come, the Sahariya was pushed to an extreme corner or *khoont*...' Thus goes a story about the origin of the Sahariyas as told by a Sahariya elder and as quoted by a Census monograph. The story goes on to say that an annoyed Brahma chided the Sahariya for his inability to cope with the pressure and decreed that he would henceforth live in forests and such other out of the way places.

The story highlights just one of the many instances in Indian history of a vanquished race losing status and esteem and becoming economically deprived. For, writing in 1881-2 (ASI Report, Vol. XVII, 1884), Alexander Cunningham identified the Sahariyas as belonging to the great race of Sauras or Savaras who were formerly the dominant branch of the great Kolian family and whose power lasted down to a comparatively late period. 'The mention of the Savaras or Sauras by both Pliny and Ptolemy is certain, and shows that they were a well-known tribe at the beginning of the Christian era, when neither Kols nor Gonds had been heard of.' Cunningham quoted other sources too and inferred that the Savaras were living in considerable numbers under their own chiefs up to the seventh (or even the eleventh) century.

The Western Sauras, to which tribe the Sahariyas of Rajasthan belong, were estimated by Cunningham to number one to one-and-a-half lakh and spread over an area of about 40,000 square miles, stretching from Panna in M.P. in the east to Mukundarra in Rajasthan, in the west. As per the 1981 Census, there were 40,945 Sahariyas in Rajasthan of which as many as 39,808 belonged to the erstwhile kingdom of Kota, which has subsequently been split into the districts of Kota and Baran. Within this domain, they, for the most part, occur in the Shahbad and Kishanganj Tehsils of Baran.

Typically, the Sahariya countenance is marked by slightly oblique 'Tartarian' eyes, broad and flat nose, rather fat and projecting lips, and a receding lower jaw, while their figures 'are generally spare and short', though they can 'endure great fatigue and are active and vigorous foresters'.

In 1965, one Census monograph described the Sahariyas as 'the most backward, hence the poorest, of the Scheduled Tribes of Rajasthan', classed as untouchables for all practical purposes. The monograph also found them to be 'much nearer to other Hindus in society than to the Bhils'. The Sahariyas in Census reports were listed as aboriginals in 1891, animists in 1901, 1911 and 1921, and as tribals thereafter. Religionwise they are, for all practical purposes, Hindu, their process of Hinduisation having been speeded up by the fact of their localities (Saharanas) mostly occurring in villages with mixed populations. Similarly, in the matter of language, they now speak 'the same Hindi dialects as the other people amongst whom they live'. Their songs are replete with references to Rama and Krishna, and the style of singing is shared with that of the Bediyas and other communities of Bundelkhand and adjoining areas.

The Sahariyas are expert woodsmen and gatherers of forest produce. They are particularly skilled in making catechu from *khair* trees. The other main source of livelihood is agriculture though their holdings are small

Bhils, Kanjars, Kathodis, Raikas...these tribal and nomadic communities of Rajasthan have done much to enrich the tapestry of life in Rajasthan. Most of them continue to be migrants by nature, and are from the areas in and around Udaipur, though the Bhils have permanent settlements in that vicinity.

Garasiya women at a community dance fest. Village temples have often supplied the anchor for such communities, establishing a link that is essential when faced with life in the hostile circumstances of the desert.

and marginal. Indebtedness and poverty are widespread. The monograph referred to earlier makes mention that 'Some ten years ago a Sahariya could be easily hired for a day on half a kilogram of *jowar* and his wife for a pitcherful of *chhachh* (buttermilk).' The influx of expert farmers has in recent years added to the Sahariyas' deprivation.

Bhils: So much has been written about the great tribe of Bhils who inhabit south-central Rajasthan that it is almost impossible to write briefly about them. As compared to the Sahariyas, they have been able to withstand detribalisation to a greater extent. But the present-day Bhil way of life traverses a wide spectrum. While a drab and deleterious deculturalisation marks the areas of intercourse with outside forces, glimpses of the old Bhil way can still be had in the interior, wooded areas of the region.

According to Bishop Heber's account penned in 1825, the Bhils are '...middlesized, slender men, very dark, with frames which promised hardiness and agility more than much muscular strength', and of 'a race whose avowed profession, from the remotest antiquity, has been plunder'. They are also 'unquestionably the original inhabitants of the country and driven to their present fastnesses and their present miserable way of life by the invasion of those tribes, ...who profess the religion of Brahma... I found that the officers with whom I conversed, thought them on the whole, a better race than their conquerors. Their word is more to be depended on, they are of a franker and livelier character, their women are far better treated and enjoy more influence, and though they shed blood without scruple

Top and above: Community, social and religious fairs provide the people of different communities the opportunity to move out of their immediate settlements, not only to celebrate, or buy, or pray, but also to see themselves as a part of an elaborate social structure.

This woman is part of a community of entertainers who also keep a record of family genealogies, placing them in great demand when the season for marriages is near, or on the occasion of family ceremonies such as the birth of a child.

in cases of deadly feud, or in the regular way of a foray, they are not vindictive or inhospitable under other circumstances...We punish them for robbing while we give them no means of earning their subsistence in an honest way.

A century-and-three-quarters later, they are hardy but averse to sustained and sedentary work, are at once gregarious and individualistic. The shrinking forest cover has affected their traditional means of livelihood and way of life and left them at the mercy of the moneylender. As usual, the development of the region has not meant the development of the Bhils, while school education is only pushing them into a grey cultural zone. However, on the whole, the Bhil still holds on to his natural good cheer, love for song and dance, a trusting disposition, and a reputation for trustworthiness.

Garasiyas: Closely allied to the Bhils, the Garasiyas

occur mostly in the west of Udaipur district and the Pindwara and Abu Road Tehsils of Sirohi district. According to the 1981 Census, they numbered 96,809. Like the Bhillalas of M.P., they are believed to be descended from Rajput fathers and Bhil mothers. The Garasiyas are a very lively lot and their women, in particular, are gaily attired.

In matters of marriage and relations between the sexes, the Bhils and the Garasiyas show an open-minded wisdom and pragmatism which is rare in the so-called upper and urbanised communities of India. In addition to arranged and regular marriage, sanction is, thus, accorded to regularised elopement as well as cohabitation after engagement but without the ceremony of marriage. Even more significant is the manner in which divorce, remarriage and widow marriage are permitted. Situations involving these and related feuds are regulated through social intervention and a system of fines, bride-price and reparation amounts variously known as *kayada*, *daapa* and *jhagada*.

Although the Garasiyas continue to have a male-dominant society as indicated by the customs of polygamy and old men marrying young girls, the status of women in these communities, particularly among the Bhils, is much higher than among the caste Hindus.

Kathodi: Seven hundred and sixty families of Kathodis reside in twenty-one villages of Tehsils Kotra and Jhadol of Udaipur district. It is said that they were brought from Maharashtra about eighty years back by contractors for making catechu. In Maharashtra, the Kathodi or Katkari are notified as a scheduled tribe. In 1961 they numbered 1,40,672, with the largest concentration in the districts of Kolaba, Thane and Pune. Interestingly, they are believed to be of Bhil origin and to have come from the north. Kathha being the equivalent of catechu, Kathodi and Katkari denote makers of catechu. In this respect they remind one of the Sahariyas and the Kheruas (from khair, the tree that yields catechu).

Writing more than a hundred years ago, H.B. Rowney wrote about the Katkaris: 'They are nomads in habit, and frequently change their place of residence, ...having their residences near, but never within, the villages inhabited by other tribes'. In my own experience, the Kathodis of Rajasthan constituted a distinct but fringe group, living as per their ancient lifestyle, with very few wordly possessions and a precarious viability.

Minas: Few communities make as fascinating a subject of study as do the Minas. They form one of the major tribes of Rajasthan with a population of over twenty

Above: The Gadoliya Lohars are a community of ironsmiths who move about in their elaborately decorated carts, and whose services are in great demand at the start of the agricultural season among rural communities.
Far left: A group of Garasiyas dancing to the pounding of a drum.
Left: A Gadoliya Lohar at his roadside smithy, while the telltale cart behind him carries all the family's material possesions.

Left: It is difficult to tell whether the skirts at the village haat or weekly bazaar are more colourful, or their customers. In recent times, the Garasiyas have taken to buying stitched clothes, though traditionally all clothes would be tailored at home.
Top: The Kalbeliyas are a community of snake charmers whose talent at singing and dancing has led to a less nomadic existence for them.
Above: These Gadoliya Lohar women continue to live a nomadic life, finding themselves reluctant to settle anywhere, though Census reports show that they are showing an increasing propensity to settle down.

lakhs as per the 1981 Census, the biggest concentration being in the districts of Jaipur, Sawai Madhopur and Alwar.

There has been considerable controversy over the origin of the Minas. According to one view, while one segment represents the remnants of a pre-Aryan, aboriginal stock, the remainder is sprung from an infusion of Rajput and other blood.

The Minas differ considerably from other tribal and aboriginal groups like the Bhils and the Sahariyas. They have fine features with aquiline noses, and this lends credence to the suggestion that they may be descended from the Shakas or Scythians. On this point, the following observation about the Parihar Minas of Khairad (area around Jahazpur) from Vol. 7 of 'The People of India' (edited by Watson and Kaye) is relevant: 'If aboriginal they show little trace of it in their appearance, in which Aryanism is highly developed. The grey or brown eyes, the fair or light brown skins, and tall stature, seem to be identical with Rajpoots....'

Like the Bhils, the Minas once ruled large tracts, including the area around Jaipur, from which they were ousted by the Rajputs. Like many other ousted tribes, the Minas, or sections among them, took to marauding. The 'Chaukidari' or 'watchmen' Minas, for example, were known for their lawlessness. The 1891 Census report for

Marwar gives an interesting account of the way in which certain Minas of Godwad and Jalore in Marwar were trained and equipped for a career of brigandage. The Minas of Khairad were particularly renowned for their valour. In fact, the Minas represented a unique amalgam of valour, trustworthiness and predation: the very people who were known for their exactions were also employed as steadfast guards. The state treasury of Jaipur, for example, was guarded by the Minas. The installation ceremonies of the Rajput rulers of Jaipur included annointing with blood drawn from the thumb of a Mina.

The Mevs of Mewat and the Mers and Merats of Merwara (Ajmer) are believed to be the kin of the Minas. The Mevs, who were Muslims but with many Hindu traits, were known for their bluntness and were once a scourge for the rulers of Delhi. The Mers and Merats had both Hindus and Muslims among their ranks, those Hindu preferring the designation of Rawat. The Mevs were believed to have had twelve clans (*pals*) and fifty-two *gotras* (including the twelve clan-names) and shared six of these clans with the Minas.

Top and above: Extensive sheep rearing is practised in Rajasthan, especially by the Raikas or Rebaris in the Pali-Jalore areas, as well as in the Marwar desert, since their coat provides the people with the wool required for their winter clothing. The Raikas, therefore, are often found on the march, rather than in settled communities.
Right: A young Bhil wears the jewellery so characteristic of his tribe, including layers of necklaces and dangling ear rings.

Above: A Raika girl in her printed clothes that speak a language of love for colour and embellishment.
Right: A Bhil elder muses on life and changing times. Known for their trustworthiness, the Bhils also have a cheerful disposition and a love for song and dance.
Far right: Confined to the Aravalli belt, the Garasiyas are believed to have descended from an inter-racial Rajput-Bhil mix, and are a particularly lively community.

VILLAGE COMMUNITIES
The Tapestry of Rural Life

Village communities provide the basis for all social life. Villages are small communities that can be called a peasant society. In a defined geographical area, from a few dozens to hundreds of families live in residential clusters surrounded by agricultural and pasture land. Such settlements take their names from those of important deities, or of a founder or his ancestor, or even on the basis of the area's geographical or social characteristics.

Rajasthan has over 35,000 villages with varying populations of between 100 and 5,000 people, with 1,000-2,000 persons being the average. Villages can be spotted from highways to which they are usually connected by narrow roads. From the distance, old, large trees can be seen. Villages are often located near village ponds or *talabs* that provide the source of water for cattle, for their residents' bathing, and sometimes for irrigation.

Such villages are usually pastoral communities, and the presence of a village is heralded by the presence, on its outskirts, of cows, buffaloes, sheep, goats, camels, and other domestic animals.

The village is such a small community that a visitor is immediately spotted, and may find himself being greeted and asked whom he wishes to see, the directions for which are then provided, or the visitor may even find himself being escorted there. It is unlikely that the roads within the village will be metalled, and most houses are connected to each other through a network of winding *kuchcha* lanes. The principal road, which may or may not be metalled, usually ends at some central point of the village. This may be a small market where people sit on the platforms at the entrances of the shops, or temples, or a small fortress, or at tea shops to exchange information, or merely to pass time, particularly in the case of senior citizens.

The doors of the houses open on to the road, and on both sides of the door there are small *chabutras* — platforms — where people sit, children play, and women discuss the day-to-day matters that affect their lives. In the centre of the village, houses tend to have more rooms, and have fewer open spaces, meeting the needs of their trader-residents. Around these are the homes of craftspeople, carpenters, Brahmins, and goldsmiths. Those who need large courtyards for their cattle and agricultural equipment are closer to the outskirts. Such agricultural families have bedrooms, stores, a kitchen, courtyard for cattle, and place for storing fodder and for keeping bullock carts or tractors. Most villages now have electricity and are connected by roads.

Roads or lanes from the village are connected with the farms, and people are associated with some form of agrarian activity. A few prosperous farmers have substantial agricultural holdings to manage irrigation facilities such as wells or canals; middle level agriculturists tend to work on their own farms; while those whose holdings are small or not arable enough find opportunities to work outside their farms. Tractors, threshers and irrigation pumps have shortened the manual work of most men on their lands.

Village communities tend to live in joint families: from their work (agricultural ploughing, irrigation, harvesting, selling) to their social concerns (attending weddings, death rituals, organising and observing betrothal and other festive ceremonies), people stay in touch, visit other villages, convey messages, and discuss daily matters. No village remains socially isolated since visits to other villages are essential for obtaining services, purchasing

Previous page: Gaudhuli, the hour of cow-dust, is described as the time when cattle come back from grazing, their hooves kicking up the sand to create a romantic, golden haze at dusk. There are several literary references to this moment, which is also celebrated in the folk songs of Rajasthan.
Above: The typical village home has a compound marked by mud walls or nettle branches, and is entered through a gateway that leads to the open courtyard where men meet, and cattle may be tethered.
Left: The art of decorating the home with simple motifs is called mandana, and is usually left to the women to develop.

169

and selling, and the important matter of arranging matrimonial alliances. Since each village has only small number of families from any one caste, and since marriage between common kin members is frowned upon, such relationships are arranged in other villages among different families of the same caste. This system enlarges the relationships between different village communities.

Almost all villages in Rajasthan are multi-caste. Traditionally, there is one or a few families of the Rajput caste who usually have larger land holdings. They manage agriculture, employing workers from other caste groups for the purpose. Some villages have traditional forts or fortresses owned by former *jagirdars* — former ruler-aristocrats of the village, but very few have been able to hold on to their ancient heritage. In a village where such Rajput clans dominate, there are also drum beaters, musicians and other serving castes to be found. A few Brahmin families in the village supervise ritual activities, work as priests in temples, convey information about fasts and festivals, and regulate the local calendar of festivals and social activities. It is a priest's responsibility to chart the auspicious day and time for beginning

Above right: A woman leads a camel to the fields. If the rains are good, the crop can be satisfying, though the task of farming is that of men, while women involve themselves with dairy production.
Above: Women lend a helping hand in the fields, a task that is rarely entrusted to them, since their chores at home are already heavy.

Far left: Women at a small village well. Since wastage of water in the desert would be unthinkable, the spillover is channelised for drinking by sheep and cows.
Left: Mustard fields brighten the landscape with their yellow flowers, a time of the year when the frost can be cold, but the season of winter is a time for celebrations all over Rajasthan.

a new venture at home or in the field. The Brahmin priests are generally also the village astrologers.

A village will in all probability also have some families from the trading caste who are also at the centre of exchanging news, supplying goods and provisions, extending small loans, and introducing new urban innovations in the village. The Jats, Gujars, Yadavs and some other castes depend entirely on agriculture. Kumbhars make earthen pots and serve the needs of their village. Carpenters are required for making and maintaining agricultural implements. There are traditional caste families to work on leather, weave cloth, grow vegetables, make ornaments, prepare sweets, clean the village; and various craftsmen, puppeteers, singers, dancers, record keepers, dyers, and printers who also occupy their place on the village ladder.

Members of many families may have to move to other villages or urban pockets to earn a living. The Rao-Bhats are family record keepers, and usually maintain the records for a number of neighbouring villages, on account of which they need to travel frequently. There are also mobile or gypsy castes who inhabit villages for specific periods of time, providing a service while they camp there. The Gadoliya Lohars, for example, are ironsmiths who live and travel in their own bullock carts, making and mending iron implements for their livelihood. The snake-charmer Kalbeliya families also move between villages, camping in family groups wherever they stop for a few days.

Nomads constitute about seven per cent of the population of the state, and of these, between one or two per cent are non-pastoral or service nomads who comprise between two to three hundred endogamous groups with occupations such as embroidery, needle-work, epic narrators, medicine sellers, fortune-tellers, artisans, genealogists, dancers, singers, and hunter-gatherers. Such nomads visit villages in regular cycles to provide each community with their services. Non-pastoral nomads offer more specialised goods and services than any other culture area since, in this desert state, villages are at greater distances from each other. Even beggars move from village to village, to collect alms, an act that is supposed to be meritorious for the charitably inclined. At harvest time, various nomads visit villages for providing important services; the visits of the Gadoliya Lohars, for example, at the start of the agricultural season when villagers require agricultural implements, is obviously looked forward to.

The kitchen in a village house is at its centre since this is where storage and cooking go hand in hand.

Above left: Though it may look makeshift, the village stove is constantly re-plastered, and consists of a wood-fired hearth on the floor over which the cooking is still done using terracotta vessels.
Far left: A Bishnoi woman milks a cow. Though cattle is kept all over Rajasthan, and in all village homes, the Bishnois have come to be regarded as a major dairy community.
Left: Such vegetables would have been unthinkable a decade or so ago. Today, with improved means of transportation, fresh vegetables have arrived at the doorstep of even the most remote village.

Families rise early, with women beginning the day's tasks with the milking of cattle. Many families maintain dairies, and carry the milk to collecting centres or to urban areas for selling.

Peasants who work on their farms leave for work after a glass of piping hot tea, carrying their spartan lunch with them. It is in the evenings that families tend to get together to dine. Generally, the male members eat first, the women next. In winter, people dine in the kitchen itself, sitting in front of the hearth. The meal consists of one or two vegetables and *rotis* (breads) on which *ghee* (clarified butter) is used. *Rotis* of wheat, maize, and millets (*bajra*) are made. Rural cooking is a simple exercise, and done by the women of the house. Villages tend not to have sweet shops, and milk and milk products — butter, buttermilk and curds — are consumed. Many communities tend to be vegetarian, and in most hamlets, these two frugal meals provide their basic diet. *Chai* (tea) is prepared early in the morning, and in the afternoon or evening, and whenever there are visitors. It is usually strong, milky and very sweet.

Each village has its own deities (*devtas*) with shrines (*devata sthans*) where the villagers go to pay obeisance. In the hot season, when most of the land has a parched and barren look, such spots are characterised by a denser greenery with most shrines of deities being pleasant spots for bathing, cooking and picnicking. These spots also provide shelter for small animals and birds. Most shrines are in the vicinity of a source of water since cleansing of oneself is a necessary part of the ritual of worship. Regional and local deities enjoy importance in villages because they may have a direct link with its people — several deities are deified saints who may have lived in the village. Pathwari, the goddess of the path, is found in almost all villages in the form of a small earthen or stone square structure worshipped whenever a person undertakes a pilgrimage. There are other mother goddesses before whom the villagers pray for shelter, nourishment and protection from disease. A village Bhairuji is a powerful deity who looks after the interests of the residents of the village. Bhairuji's shrines are rarely in the form of a temple, a stone platform being enough representation. Sagasji is another local deity who offers protection for harvests and animal life. Generally, Sagasji is propitiated on the boundary of a farm, or near an irrigation well. Regional heroes such as Deo-Narayanji, Gogaji, Tejaji and Ramdevji are worshipped in villages.

Above: The akhara or wrestling pit may not attract too many warriors these days, but wrestling is still a sport that all villagers gather to enjoy as spectators.
Far left: Opium is strained for use in some rituals in which the people may still participate. The use of opium was fairly widespread in the medieval ages, at royal manwar ceremonies, and as a mark of a friendly welcome in Bishnoi villages, but its use has been severely curtailed now, and the rituals are a mere observance.
Left: A man milks a camel, its thick, sweet milk not too popular among the people, though it still finds usage in the western districts of the desert.
Following page: Red hot chillies dry under the sun at Nagaur, the world's largest chilli growing belt.

Right above and below: The division of chores is such that women fetch water, cook, tend to the cattle, and look after the homes. The men, on the other hand, are concerned with work outside the home, whether farming, taking the cows and sheep to pasture, or running errands to the nearest towns. Mixed gatherings of men and women may happen only within the confines of the home, never outside.
Far right: A couple shares an intimate moment at the Pushkar fair. On occasions such as these, women step out into the fairgrounds for probably one of few opportunities they have of being away from the confines of their homes and villages.

Pauranik or pan-national gods are worshipped in the temples devoted to Krishna, Rama and other incarnations of Vishnu. Shiva temples are also popular in villages. In villages where Muslim families have their homes, a mosque or a roadside shrine of Pir Baba can also be found.

In a cluster of villages, one deity is usually more powerful or popular for a particular power or authority. In rural life, the attitudes ascribed to gods and human beings are closely homogenised. No wonder their shrines enjoy protection, as do the trees around them, and are regarded as sacred groves.

Fairs and festivals lend vibrancy to village life. A large number of fairs are organised in rural areas, and the rural population turns up in volume to attend urban fairs. Such fairs have a mixed commercial and religious aspect. At the Pushkar fair, for example, cattle and camel trading is combined with the annual pilgrimage to the temple of Brahma for ritual bathing and worship. Villagers use such opportunities for buying the things they do not usually get in and around their villages. Women buy dresses, mirrors, utensils, printed bedsheets, bangles and toys for children. A village fair offers all the attractions and enticements of a circus-cum-bazaar: there are entertainments on offer, sweet shops, and handicraft stalls.

Festivals are celebrated as family or community events. On the occasion of Gangaur in the month of Chaitra (March-April), for example, spread over fifteen days, young unmarried girls and those recently married visit gardens in groups to bring flowers and water pitchers and worship Gor Mata, the mother goddess, for being blessed with an ideal husband, or for the husband's well-being. Teej is celebrated in the rainy season, a festival again for women, and linked with marital celebrations. Unmarried girls keep a fast on all Mondays to pray to Shiva for a husband of their choice. Amavasya, the dark night, is considered inauspicious by villagers who

Above: Men accompany their camels either on foot, or riding on their backs, but women make the journey on wooden carts pulled by camels. Incidentally, the tyres used in these carts are those disposed after the mandatory number of landings required of an aircraft.
Facing page: At local fairs, part of the excitement is the pavement markets where villagers come to shop for everything from simple implements and tools to utensils and jewellery.

neither buy nor sell anything on that day. Craftsmen, milkmen, farmers and vegetable sellers do not work on that day. On festivals such as Holi, Diwali and Rakhi, rice and sweets are cooked as consecrated offerings for the gods.

The tradition of telling stories on those days when people observe fasts also remains popular. On such occasions, the women from the same neighbourhood tend to worship together, and recount tales related with the fast: remembering myths and history is one way of transmitting culture from one generation to the next. Each village or even its trees (this is desert country) have histories of their own, and many of the tales deal with cataclysmic natural or historical events, or those associated with modernisation (the construction of a railway line, or a school building, for example).

Music is the lifeblood of village life. Songs are sung on a variety of occasions — from childbirth to marriage, festivals, and at work: as they work in their fields, or at home, when they take their cattle to the pasture, or when they walk for long distances. Through music, traditions

181

are expressed and social systems strengthened. No festival is complete without music. *Bhajans* or devotional songs also form part of their repertoire. On various family rituals, neighbours and relatives are invited to sing, especially at the time of *Ratijaga*, a ritual when women have to stay awake through the night, singing songs devoted to their ancestors and deities. Villagers also welcome and bid adieu to their guests with songs.

Dancing, too, is part of community culture. In village life, group dances are preferred, and men and women dance in separate groups.

In traditional villages, there are professional castes employed for the purpose of singing and dancing for their patrons. One or more Dholi – the drum beater caste — is attached with a village. This family has rights and obligations to serve the village for drum beating and singing. Mirasi, Langa, Dadhi, Kalavant, Bhat, and Rao are also castes who sing, dance and maintain family records of their patron castes. Every caste looks to the Rao-Bhats to maintain its family records, in books or orally, and to sing the praise of its patron families on the occasion of births, marriages and deaths.

The window to the village world is small, confined to life around the home, but the people of Rajasthan bequeath it with such vibrance that each day opens like a celebration. No wonder the people spend so much time and effort in embellishing their surroundings.

Though folk musical instruments are often simple and even improvised from kitchen utensils — the *thali* or metal platter, for example; *katori* or metal bowls; cups; fire tongs; the earthenware pot; — others include the *jantar*, *ravanhattha*, *tandoora*, *ektara*, *bhapang*, *kamaycha* as string instruments, while flutes, *pungi* snake charmers' flutes, and *dhols*, *dholaks*, *nagaras* and *changs* (all drums) are popular with folk musicians.

Rural women dress colourfully, with reds and yellows dominating their colour aesthetics. They wear ornaments such as earrings, bracelets and rings to indicate their position in the village heirarchy. One's wardrobe in the village defines the wearer's geographical and social identity. From the *safa* to the clothes men sport, or women wear, everything is indicative of the role one plays in society, and on one's individual status in life.

Agricultural castes have a definite preference for colours that are particular to them. The *ghaghara* or skirt is generally in a dark shade such as deep green or dark blue while the *odhani* is usually a brighter shade of red or yellow or pink. The ornaments are representative of certain social groups. The higher the caste group, the lighter its use of dress (material and colours) and ornaments. At the highest scale, fine fabrics and ornaments made of gold are preferred. But in rural areas, silver ornaments are more usual. Silver jewellery is usually heavier and uses intricate, ethnic designs. Traditional patterns are used for making necklaces, earrings, bangles and anklets. Rings are worn on fingers and on toes. A newly married woman is expected to wear the *bor* on her head at all times, while the *kankati* or waist-belt, and bangles of lac and glass continue to enjoy vast patronage.

Though villagers are hopeful of maintaining their traditions despite the onslaught of modern life, there are some visible changes in their lifestyle. The traditional *jagirdari* system is long over and villagers are now owners of their own land. The village *panchayat* system has been revived and the elected village *panchayat* looks after the village administration and development activities. Villagers now point to a *pucca panchayat* office, a primary school, a handpump, a playground and other community assets as signs of progress.

Agricultural activity is looked after and helped by government departments; cooperative banks provide loans and new varieties of seeds, chemical fertilisers, medicines and seedlings; most villagers now have enough electricity to run irrigation pumps; drinking water facilities have been created in almost all villages; dispensaries and medicines are not far off from villages; roads have joined villages with towns, and regular buses and other means of transport are available; television sets and radios are providing the basis for more changes in rural life; telephonic communications link the smallest village with the world outside; cinema and newspapers are reaching across to them. But even as changes are being brought about in their lifestyles, the villages continue to be the heart and soul of Rajasthan.

Top left: The boundaries of a village are sometimes marked by cenotaphs raised to their heroes, in the shadow of which the people go about their everyday lives, sure of their tradition.
Far left: Women veil their faces from public gaze when travelling, even in groups, taking their colourful life with them wherever they happen to be.
Above: Cows are used to pull the wheel of the well for watering the fields or for their cattle. Such shallow wells rarely provide water for drinking.
Left: The laughing face of a girl at a fair. To most visitors, it appears that the hostile environment has brought out the most positive spirit in the people of the region.

Above and right: A woman's chores never end, but she does them uncomplainingly, and with her dash of colour and vibrance, whether it is filling water from a tap (a rare luxury still), winnowing, taking care of children, or participating in a cook-out at a fair camp.
Right: Occasionally, though, they let down their hair, as they let the wind billow in their skirts and mantles, while participating in a community celebration, such as a: Teej when swings are a mandatory part of the observance of the ceremony on that day.

Acknowledgements

This unusual book that provides an insight into the lesser-known life of the people of Rajasthan would not have been possible without the collective effort of the many people who have worked on it. But even before the book came the genesis — the idea that sparked it off. For that, I would like to thank the Ministry of Tourism, Government of Rajasthan, in providing the support for making this venture possible. In particular, Smt. Bina Kak, Hon'ble Minister for Tourism, Art and Culture, Government of Rajasthan, who has been instrumental in working closely with the project, even checking the pictures and ensuring that nothing short of the best, or the essential, have been used. Along with her, I would also like to thank Shri Lalit K. Panwar, Secretary Tourism, and Shri Shailendra Agarwal, Director of Tourism, for their support, encouragement and willingness to see the book through despite a very tight schedule.

I would also like to express my gratitude to Shri Shrawan Sawhney, Additional Director Tourism, Shri Raghubir Singh, Assistant Director Tourism, and Smt. Monica Lather, Assistant Director Tourism, who worked round the clock to help assemble this project. Without their guidance and support, this project would not have been able to achieve its tight deadline.

Among those who helped to read the manuscripts and offered valuable suggestions and relevant changes, I would like to particularly thank Dr. Vijay Verma, Shri V.K. Gaur, and Prof. Ishwar Modi who took time to ensure that the book is as accurate in its representation as is possible. Any omissions or mistakes are not of their making, but my doing.

Of course, the many authors and photographers who worked for the project also have my gratitude. Without them, the book would not have happened. I am grateful to Shri Kishore Singh for editing the manuscript & providing valuable contribution to the book. As for the many other people who worked on the book at the pre-press and press stage, their anonymous effort has my heartfelt and sincere thanks.

ASHWANI SABHARWAL
Publisher

Photo Credits

Aman Nath/Francis Wacziarg 26B, 32B, 36A, 66B, 117A, 142B, 174-175.

Amrit P. Singh 65.

Anil Gaba 1, 78-79, 87A, 95A, 121, 122-123, 128F, 132-133, 170-171.

Anwar 99A, 110B, 115A, 129E.

Arun Mudgal 170B.

B.N. Khazanchi 80-81, 81A, 86A.

Col. HVC 30-31

Dr. Reepunjaya Singh 29, 111.

Gopal R. Kumawat 8-9.

Gopi Gajwani 54B, 100, 113A, 134-135, 186A, 186A.

Hari Krishan Jha 24B, 46A, 55B, 70-71, 74A, 77, 107A, 119.

J.S. Olaniya 106B, 107B, 140-141, 180-181.

K.K. Agrawal 46B, 52B, 73, 148-149, 158-159.

Kaneej Bhatti 133B.

L.S. Tak 12-13, 27A, 131, 168-169, 171A, 176-177, 182-183, 186B.

Liaqat A. Bhatti 64B, 72C, 113B, 114B, 128B.

M.D. Sharma Cover, 45B, 66A, 72B, 82-83, 85C, 93C, 137, 179, 183A, 185B.

Manu Bahuguna 18, 19, 20A, 20B, 24A, 129A, 170A.

N.L. Jewaria 36-37, 38A, 40B, 40C, 41, 48-49A, 48A, 51A, 56-57, 64A, 67, 75A, 84A, 85B, 114A, 178A.

N.S. Olaniya 37A, 47B, 104A, 142A, 169A, 182A.

Phal Girota 38-39, 45A, 49A, 104E, 105.

Pradeep Soni 91A, 93A.

Raghubir Singh 98-99, 125B (back cover).

Raj Chauhan 80A, 106A, 160.

Rajpal Singh 4-5, 10-11, 22-23, 25, 27B, 34-35, 44A, 59A, 74-75, 76C, 86 87, 96B, 97A, , 99B, 103A, 135A, 135B, 138A, 138B, 139A, 144-145, 146-147, 146A, 148-149A, 154, 155, 156A, 161B, 162B, 181B, 184A.

Robert Huber 2-3, 14-15, 16-17, 21, 28-29, 32A, 39A, 47A, 48-49, 50-51, 52A, 54A, 61A, 62 63, 68A, 68C, 69, 72A, 76B, 84B, 93B, 96A, 102-103, 108, 109, 110A, 112A, 112B, 115B, 129D, 150A, 150B, 166-167, 172A, 173A, 174A, 178B, 181A.

Rupinder Khullar 82A, 124, 126B, 129B, 136A.

Subhash Bhargava 6-7, 26A, 33, 40A, 42-43, 44B, 51B, 53A, 53B, 55A, 58-59, 60A, 60B, 61B, 68B, 83A, 85A, 88-89, 92, 94, 95, 98A,106C, 118B, 118C, 120C, 125A, 125C, 126-127, 126A, 128A, 128C, 128D, 128E, 130, 139B, 140A, 140B, 143, 149A, 151, 156B, 157, 159A, 172-173.

Sudhir Kasliwal 115C, 117B, 120A, 120B.

Suraj N. Sharma 76A, 133A, 134, 165, 187.

Surender Sahai 90, 91, 97B.

Thomas Dix 116-117, 118A, 185A.

Thomas Kummerow 102A, 175A.

V.D. Sharma 136C, 147A.

Vijay Verma 136B, 152-153, 152A, 153A, 153B, 153C, 158A, 161A, 162A, 163, 164A, 164B.

The pictures of jewellery & artefacts are courtsey Gem Palace, M.I. Road, Jaipur & Amarpali, Panchbatti, Jaipur.